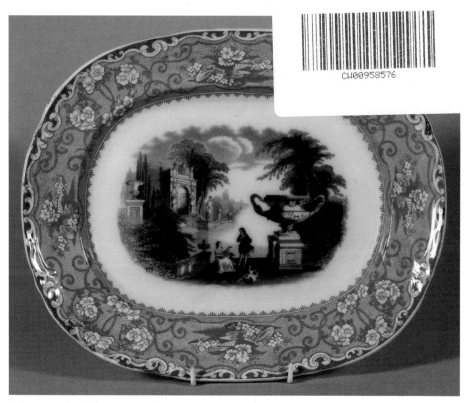

Ashet printed with 'Warwick Vase' pattern by J. & M. P. Bell & Co of the Glasgow Pottery. This was the only Scottish pottery design to be registered twice (in 1850 and 1890); the actual Warwick Vase is now on display in the Burrell Museum, Glasgow. Dual colour printing is almost unknown for the domestic market.

Scottish Pottery

A brief history

Graeme Cruickshank

Published in 2010 by Shire Publications Ltd,
Midland House, West Way, Botley, Oxford OX2 0PH, UK.
(Website: www.shirebooks.co.uk)

British Library Cataloguing in Publication Data:
Cruickshank, Graeme D. R.
Scottish pottery. – 2nd ed. – (Shire Library; 191)
1. Pottery industry – Scotland – History
I. Title 338.4'76666'09411
ISBN-10: 0 7478 0639 X

Cover: *Jug with hand-painted relief decoration depicting fisher folk; a fisherman in thigh boots with nets over his shoulder is shown departing for the sea, while a fisherwife with a laden creel in front of her prepares to sell the catch through the streets (shape registered in 1867). Made by the Glasgow Pottery of J. & M. P. Bell, arguably the most prolific of all the Scottish potteries. Vase of classical shape (sometimes called a campana), with fine hand-painted decoration and abundant gilding. Made of Nautilus Porcelain by McDougall's Possil Pottery, Glasgow.*

NOTE ON ILLUSTRATIONS
Each item of pottery illustrated in this book bears the maker's mark of the factory where it was produced, unless otherwise stated. Where an attribution is given, it is on the basis of historical, documentary, archaeological or some other form of evidence. Principal photographer: Angus McComiskey, Edinburgh. Photography of makers' marks: Jill Turnbull, Edinburgh.

ACKNOWLEDGEMENTS
I would like to thank many friends, members of the Scottish Pottery Society, and former museum colleagues, for their assistance and encouragement over a long period, which did much to develop my interest in the whole field of pottery production in Scotland. Without that, I would have been ill-equipped to write this book.
 Illustrations are acknowledged as follows: anonymous book *Britain at Work*, 1902, page 40; Blair Castle Archives, Perthshire, page 10 (lower); A. W. Buchan & Co, photograph by A. G. Ingram Ltd, page 41 (upper); Comptroller of Her Majesty's Stationery Office, page 14 (both); Falkirk Museums, page 45; Jack Fisher, photographer, Portobello, page 41 (lower); Glasgow University Library Special Collections, page 12 (upper); National Archives of Scotland, pages 9 and 11; National Archives of the UK, page 13 (both); Miss Mariebell Nekola, page 33; Scottish Pottery Society Archives, page 29; Society of Antiquaries of Scotland, page 4 (both); Trustees of the National Library of Scotland, page 28; Trustees of the National Museums of Scotland, page 10 (upper). The photograph on page 47 is by the author.

Printed in China through Worldprint.

3

Contents

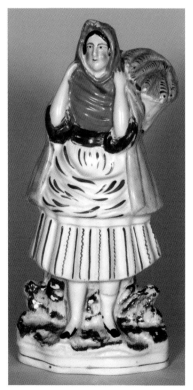

Figurine of a fisherwife in traditional costume bearing a full creel, of the kind once to be found on nearly every mantelshelf in the cottages of fishing communities; attributed to Belfield of Prestonpans.

Pre-industrial pottery

The production of pottery in Scotland is an ancient craft, dating back to prehistoric times. Although hand-modelled, unglazed, and coarse-bodied by modern standards, much of this pottery exhibits shapes and decorative techniques of some sophistication. Such items include Neolithic bowls going back to around 4000 BC, and Bronze Age beakers going back to around 2400 BC.

Half a dozen sites in Roman Scotland offer the suggestion of pottery production, though during the Dark Ages there are few indications of pottery making or even of pottery use. Before the days of regular trading in bulk this is hardly surprising. Those areas where there was no naturally occurring clay could not support the making of pottery, nor would the people in such areas have regarded it as a requirement if the countryside was wooded, as wooden vessels were very much simpler to make. This resulted in an aceramic culture in some areas, which was to persist to some extent right through into the industrial era, and not just in less accessible places.

There is growing evidence for extensive pottery production in medieval times, with imports of similar material from England and the Continent gradually tailing off. Slight differences in fabric content and surface finish suggest that many burghs supported a local pottery in their vicinity – but not in the towns themselves, perhaps because of the risk of fire arising from the storage of combustible materials and the sparks and embers produced by the

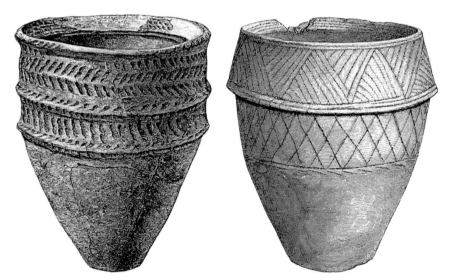

Two East Lothian funerary urns, one from Birseley near Prestonpans, the other from Kirkpark near Musselburgh, which date back close to 2000 BC, thereby presaging the industrial potteries in these two towns by more than three and a half millennia.

firing process. Those pottery sites which have been positively identified are certainly of a rural nature, such as Colstoun in East Lothian, Stenhouse in Stirlingshire, and the burgh of Rattray (now gone) in Aberdeenshire. A swathe of the Carse of Stirling supported what almost amounted to an industry, centred on Throsk.

Standards were variable: the Rattray products were skilfully made, having a fine fabric and thin walls, while elsewhere there are instances of heaviness caused by poor throwing, sometimes corrected by knife trimming. Vessels generally took the form of jugs and cooking pots; later came skillets and bowls. Sometimes less common items were made, such as candlesticks, ointment jars and *pirlie pigs* (earthenware money-boxes), which were roughly spherical in shape with either vertical or horizontal slits to take the coins. Decoration was applied by various techniques – stamping, rouletting, slip trailing and modelling, the last being best exemplified by the humorous face masks to be seen on the spouts of many flagons. The main types of glazes and the resultant colours were copper giving green, iron giving black and manganese giving brown.

It is not only archaeology which can indicate the presence of potteries that have long disappeared. Place-names often contain vital clues, such as an entry in the Church Book of Scone, near Perth, which makes reference to one of the abbey's landholdings in 1452 by the name 'Lamepottis'. This is suggestive of pot-making, though it may not be regarded as providing actual proof. Clayhills near the Dee estuary was the site of the original ceramic industry in Aberdeen in the later eighteenth century; the nearby Potter's Creek provides another pointer. Clayslaps Road near Glasgow's Kelvingrove may sound an echo of an erstwhile pottery. Potterland in Kircudbrightshire (a name which still exists in half a dozen closely grouped topographical features) refers to a pottery that was already regarded as 'ancient' at the end of the eighteenth century. Map evidence showing actual potteries can be of great importance, illustrating both the growth of the industry in its early days (see Ainslie's map of Portobello, 1787, on page 9) and providing details of what it was like in its heyday (see the Ordnance Survey map of 1910 which includes the Barrowfield Pottery in Glasgow, on page 28). In Clackmannan the name of 'Pottery' remained on maps, and in local parlance, long after the pottery itself had disappeared and been forgotten. There are many more examples.

There are very few records referring to potters in the pre-industrial period, and those which are found must be treated with caution lest they refer to metal-workers, that is, makers of pots and pans. The key word is *lame*, an old term meaning china or earthenware. Several references occur in the Treasury Accounts during the sixteenth century, the earliest one noted dating from 1501: 'to the pottair, for laym pottis, v s' (5 shillings). This is the earliest known contemporary reference to pot-making in Scotland. Barely six months later, the earliest written place-name associated with a potter appears: 'giffen to the pottair of Linlithgow for lame

pottis, ix s' (9 shillings). In 1521, the records of the Burgh of Stirling mention a *pigmakar* (potter) named Moffat who was in Stirling in that year. This provides the earliest known name of a potter in Scotland.

Only occasionally do we get even the briefest indication of the progress of pottery making before the introduction of the factory system. There is evidence of considerable activity in the year 1619, the most important development being a licence granted to John Stewart, Lord Kincleven, and his heirs to make 'all sorte of earthin vessellis and wark of clay, tyill, morrill, not heirtofoir practiseit within this kingdome'. The king, James VI, expressed the wish that such work be carried out in Scotland, both to keep his subjects employed and to prevent money leaving Scotland to buy wares abroad. The Privy Council noted that this licence did not prevent earthenware continuing to be made in the accustomed manner.

The transition from small local pottery to commercial factory was a big step, and it was slow in coming, for Scotland took some time to become an industrialised nation. Pottery was not among those industries which were first to prosper, and an opportunity was missed in 1681 when it was omitted by Parliament from the list of industries contained in the Act for Encouraging Trade and Manufactures. However, the Act was prophetic in its inducement to skilled foreign artisans to settle in Scotland, for the young pottery industry owed much of its successful growth to the arrival of incomers, some from the Continent, but mostly from England, before native enterprise fashioned it into a major element in the economy of several of the nation's principal burghs.

Before that was to happen, however, Scotland had to endure a period of severe privation, as the seventeenth century gave way to the eighteenth – the famine of the Ill Years, and the financial disaster of the Darien Scheme. Even so, in 1695 Parliament heard the draft of an Act to establish a pottery, though the idea appears to have gone no further. In 1703 it passed an Act allowing a pottery producing lame, porcelain and earthenware to be set up, awarding its proprietors a fifteen-year monopoly. There is no evidence as to whether or not this was ever translated into reality.

The earliest known published reference to a named pottery occurs in Sir Robert Sibbald's *History of Stirlingshire* of 1710, in which he refers to Throsk: 'Here is a Potterie, where Earthen Pots and severall other Leam Vessels are made.' The precise site of this pottery is not known, as its kiln foundations have yet to be located, but enough is known of the products through sherds, including wasters, to indicate that it was essentially an old-style country pottery rather than a pottery factory. The union with England occurred in 1707, but the anticipated benefits were a long time in materialising and the eighteenth century was almost half over before the Scottish pottery industry got under way in earnest.

The advent of the factory system

The nature and scale of pottery production in Scotland altered radically during the second half of the eighteenth century. After a long period of stagnation the Scottish economy at last revived, and a number of infant industries began to establish themselves. Pottery making tended to gravitate towards those areas which could supply its basic needs: clay to make the pots, and coal to fire them; sufficient labour not only to man the factories but also possessing the aptitude to learn new skills; a ready means of transporting the finished ware in bulk, which in those days generally meant going by sea, coupled with a proximity to population centres and the markets which they could provide.

Two districts were of crucial importance in the early days of the Scottish pottery industry: Glasgow, and a group of East Lothian townships to the east of Edinburgh. Skilled English artisans were encouraged to settle in both places and, although their early endeavours had mixed results, their knowledge provided the necessary toehold for the industry to become established and then to expand from the sound platform of experience gained by the Scottish workforce.

Often cited as the earliest true pottery factory in Scotland is the Delftfield Pottery, which was founded in 1748 by the banks of the river Clyde at Broomielaw in Glasgow (though at that time outwith the bounds of the burgh). At last, pottery was being manufactured

Five examples of redware (russet earthenware – see the bottom section of the small pot towards the left), made from local clays and sold or bartered locally. White slip (very liquid clay) was used extensively – three of these pots show the effect of slip dipping, and two exhibit slip trailing. The two large items are (centre) a cheese dish and (right) a 'saut bucket' (salt container). Domestic items such as these were made by many 'country potteries' (some of which flourished in towns) over a long period, even intruding well into the industrial era, but are scarcely ever marked.

in Scotland according to the industrial process, but the new venture had many problems to overcome. To begin with, skilled labour had to be imported. This was acquired initially in the person of John Bird from the Lambeth Pottery in London, though there are several conflicting accounts as to how he was persuaded to move to Glasgow. Bird was not regarded kindly by his fellow workers at Lambeth for taking the specialist trade of delftware out of his native country.

The Delftfield Pottery did not achieve immediate success, and indeed a combination of misfortunes very nearly killed the venture in its infancy. The buildings were very substantial but lacked accuracy in their dimensions, so that the kilns were not enclosed within them as they should have been. The local Germiston clay, despite being examined by John Bird and passed as suitable, was useless for making delftware, and supplies had to be obtained from Carrickfergus in Ireland, all the while keeping the purpose secret from rival delftware potteries in Liverpool and Bristol, both of which shared that source.

The first bisque firing at Delftfield was a total disaster, as the kiln was fired too rapidly and the stacks of saggers keeled over, destroying the wares inside and choking the flues so that the workshops were filled with dense smoke. The first glost firing was also a complete failure, for the roughness of the glaze finish made the ware unsaleable; Bird blamed impurities from the grinding stones affecting the chemical composition of the glaze mix, but it was discovered that the glaze components had simply been weighed out incorrectly. Finally there were liquidity problems caused by the loss of whole kiln-loads of goods and the consequent lack of income, while at the same time there were heavy outgoings for materials and also the high wages being paid to John Bird, several other former Lambeth potters, and one from Holland.

It was therefore something of a triumph when at last the pottery was able to advertise in the local press in April 1749 that its wares were 'now made to great perfection'. This came too late to save

A creamware jug, probably from a Forth coastal pottery, typical of the first period of industrialisation, produced with a degree of elegance and refinement. The decoration includes pink lustre.

John Bird, who had been dismissed for incompetence, though he fought a successful action against the company in the Court of Session. It did, however, establish Delftfield Pottery as a successful venture which was to endure well into the nineteenth century. It diversified its range of production, one interesting feature being the development of creamware, in which the inventor James Watt was instrumental, communicating the results of his trials with clays and glazes to Josiah Wedgwood in Staffordshire.

Meanwhile, in eastern Scotland, the ceramic industry was also starting to develop. Along the southern shore of the Firth of Forth, to the east of Edinburgh, potteries of no small importance started up in a string of coastal townships (or in some

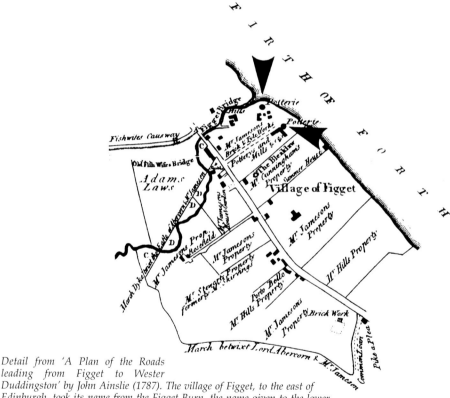

Detail from 'A Plan of the Roads leading from Figget to Wester Duddingston' by John Ainslie (1787). The village of Figget, to the east of Edinburgh, took its name from the Figget Burn, the name given to the lower reaches of Duddingston Burn. The village was later known as Portobello; the original Portobello hut ('huts' being the country lodges of the city gentry) can be seen towards the south. The major landowner is clearly flagged as 'Mr Jameson', whose name appears on half a dozen properties. This was William Jameson, an Edinburgh mason, builder and architect, who was the first person to exploit the rich clay beds here in 1763, initially to make bricks. An annual output of three million bricks, for home use and also for export to the Continent and to the Americas, led to the village being known as Brickfield for a time. Significantly, his most northerly property is captioned 'Mr Jameson's Brick & Tyle Works, Potterys and Mills, &c, &c.' Immediately to the east of the estuary of the Figget Burn two round structures can be seen, each captioned 'Potterie' – sound evidence that the pottery industry of Portobello was well under way by this time, though the precise nature of its products is still largely a matter of conjecture.

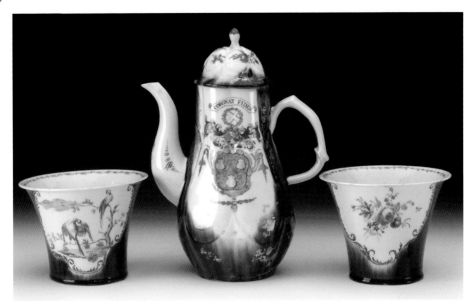

Porcelain coffee pot and pair of jardinières, attributed to Littler's West Pans Pottery, East Lothian. They are extremely finely painted, and the coffee pot carries the arms of Pringle of Stichill in Roxburghshire, an example of Littler's desire to cater particularly for the aristocracy. The pieces also display large patches of what became known as 'Littler's Blue' – a strong blue coloration, which was derived from cobalt obtained from the silver mines at Alva in Clackmannanshire and refined at Roebuck's chemical works in Prestonpans.

cases the township grew up around the pottery). These potteries were at Portobello, Musselburgh, West Pans, Morrison's Haven, Cuthill and Prestonpans. The last-named was the first to go into production, with the establishment of William Cadell's Pottery in 1750. White salt-glazed stoneware was one of their early lines of production. Even though the pottery widened its range, John Cadell (son of the founder) was a canny businessman, and his

Printed billhead from the West Pans Pottery of William Littler, his client being the third Duke of Atholl in Perthshire. It gives interesting details of the range of china produced at West Pans and also illustrates a punch bowl. The bill is dated 8th October 1766.

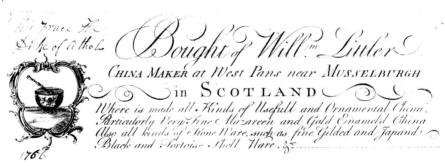

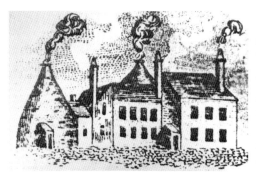

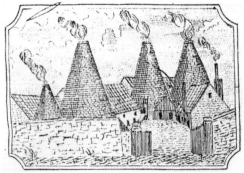

Two depictions of early nineteenth-century Scottish potteries in production, taken from printed billheads. (Above) The Portobello Pottery of Thomas Rathbone, showing two kilns, three tall chimneys and substantial two-storey buildings. The bill is dated 11th April 1825. (Below) The Newbigging Pottery, Musselburgh, of William Reid, showing four kilns, a chimney and a cluster of low buildings. The bill is dated 12th April 1839. Such depictions are rare, though were it not for illustrated billheads we would have little idea of the physical appearance of the old Scottish potteries.

These two examples date from a period before the industry had reached its height, and neither of the kilns shown is typical. Rathbone betrayed his likely Staffordshire background by his use of bottle-shaped English-style kilns, while those of Reid were conical, similar to the kilns of a glassworks. The typical Scottish pottery kiln was a cylinder surmounted by a cone, as at Buchan's Pottery (see page 47).

Edinburgh warehouse advertised both his own products and Staffordshire imports, for which he acted as agent. Nevertheless, he expressed the hope that his own wares would 'give equal satisfaction to those that wish to encourage the industrious amongst our selves'.

Of the other East Lothian pottery-producing townships, one of the most interesting was West Pans. The pottery there was started around 1754, and a decade later it was taken over by William Littler, who had previously been a porcelain potter at Longton Hall in Staffordshire. It was once thought that Littler's operations at West Pans were confined to decorating ware brought north from Longton Hall and, while it is possible that this occupied part of his attention in the early days, it is clear from his press advertisements that he developed the Pottery into a lively and innovative manufactory.

To offset the isolated location of West Pans, William Littler adopted a vigorous marketing policy, renting rooms in city centres for a week at a time and offering for sale a wide range of his manufactures. His venue in 1765 could hardly have been more prestigious – a commodious room in the Palace of Holyroodhouse. He repeated his strategy in the following year in a room in Abbey Strand, just outside the palace gates, and in Aberdeen in the next two years. It would seem that his products were well received, and in 1774 he announced in an advertisement that 'the proprietor has

Woodcut of Agur's Pottery, Glasgow, 1787. In that year John Agur relocated his brick and tile works and also constructed a pottery. The press advertisement to announce the change was illustrated by this woodcut. If this is an actual representation of the potworks, then, at this fairly early stage in the industrialisation of pottery production in Scotland, it looks as if it was (in some instances at least) still a cottage industry in the literal sense. To either side of the works there appear examples of two of its principal lines – a flowerpot and a sugar-loaf mould.

invented a new and beautiful purple-coloured ware, and a sky-coloured ware'. Although West Pans was destined not to become a major commercial concern, William Littler was justly proud of his achievements, proving himself both enterprising and inventive, and his legacy was considerable.

He is also reputed to have produced a rich mazarine blue. Correspondence shows that this colour, known colloquially as 'Littler's blue', was derived from cobalt obtained from the silver mines at Alva in Clackmannanshire. This proved to be of very high

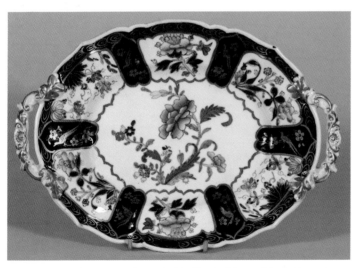

An elegant little dish bearing the mark of Geddes & Kidston of the Anderston Pottery, Glasgow (see page 60). Its high quality is reminiscent of Derby china of the period, and there is indeed a strong possibility of an English connection, for Arnold Fleming recorded that links existed between Staffordshire and these two Glasgow partners. John Geddes is known to have employed a potter from Wedgwood's Etruria factory at the Verreville Pottery in Glasgow, while Alexander Kidston, upon gaining control of Verreville a few years later, reportedly induced skilled potters, flower painters and gilders to come from renowned English works such as Derby and Coalport. Their influence, and perhaps even their handiwork, may be evident in this piece.

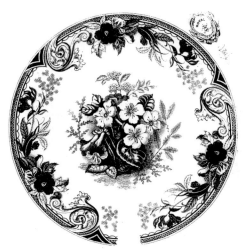

Two registered designs, one for a pattern, the other for a shape. The proprietors of the transfer-printed pattern (left) were J. & M. P. Bell of the Glasgow Pottery. The design, a finely engraved botanical grouping named 'Royal Conservatory', was given the registered number 104317 (first series), dating it to 1856. This illustration shows a pull taken from an engraved copper printing plate; the central printed design will lie flat on the ceramic plate to which it is applied, but the border design, being applied to the inwardly tilted rim, does not form a complete circle – a gap is visible at the bottom, the two edges of which will join together when applied. Also engraved in one corner of the square copper printing plate is the maker's mark, including the pattern name and (faintly) a registration device in which the coded characters have yet to be entered (for a completed registration device, see page 60 no.3).

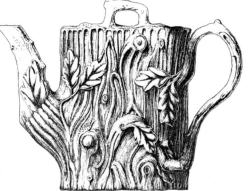

The proprietors of the moulded pattern (right) were W. & J. A. Bailey, Alloa Pottery. This design, redolent of the Arts and Crafts movement, was appropriately named 'Rustic' and was given the registered number 265255 (first series), dating it to 1872. Although only the teapot appears in the folio of representations, the design also applied to other items in the tea-set. Similar teapots were produced in England by the Spode, Rockingham and Ridgway factories, but they lack the verve of the Alloa version.

quality when analysed by the renowned physicist Professor Joseph Black at Glasgow University (and it is likely that it was used at Delftfield Pottery as well). This news excited the interest of several porcelain-manufacturing centres in England, such as Worcester, Derby and London.

Much more enigmatic are the products of Alexander Lind of Gorgie (a western suburb of Edinburgh), who may have been making porcelain there in the period 1746–56, under the patronage of Archibald, third Duke of Argyll. There certainly was a china manufactory at Stockbridge (a northern suburb of Edinburgh) in the early nineteenth century, as press advertisements and maps testify, but as yet none of its products has been positively identified.

It would appear from the little we know that most factories tended to remain quite small in scale for the remainder of the eighteenth century. This would seem to be true of those operating in the East Lothian coastal townships and at Cousland to the south, and in other towns on the Forth estuary such as Bo'ness and

Two patented designs taken out by Grosvenor's Eagle Pottery, Glasgow, one relating to an object and the other to a process. Frederic Grosvenor was the most inventive of the industrial potters in Scotland. (Left) A patent for 'improvements in jars', 1899. The novelty of the idea was that jars used to contain dangerous and noxious liquids should be provided with a means by which the contents might be poured more easily, as shown. The air inlet at the top of the handle could be readily blocked by a finger or thumb to control the outflow of liquid. (Right) A patent for 'improvements in apparatus for shaping clay ware', 1884. The novelty of the idea was that the articles to be shaped should be held stationary while the shaping tool itself was rotated.

Kirkcaldy. A similar situation existed in Glasgow where the focus shifted from west to east. The burgh of Calton, with its rich clay deposits, gave rise to a number of brickworks, several of which developed into small potteries. Although still in its infancy, the Scottish pottery industry was by now well established, and although some of its early progress was faltering the basis had been laid for the great boom in industrial pottery production which occurred throughout the nineteenth century.

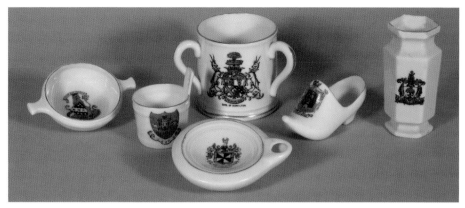

A group of porcelain miniatures of a type known as 'crested ware' – though they almost always carry the full achievement of arms and not just the crest. All bar one are examples of Nautilus porcelain, made at the Possil Pottery in Glasgow. The four on the left are all modelled on traditional Scottish items of utility – a quaich, a luggie, a cruizie and a three-handled loving cup. Dozens of Scottish burgh coats of arms appeared on such items, though the clog carries that of Sherborne in the far south of England. Ironically, the little vase on the right, which bears the arms of Glasgow, was not made there but at Prestonpans, being an example of Coral porcelain.

The scope and range of the industrial potteries

The level of production of Scotland's burgeoning pottery industry increased throughout the nineteenth century, and the range of wares made covered the entire ceramic spectrum. Fine porcelain was produced in Glasgow ('Nautilus' at Possil Pottery) and in Prestonpans ('Coral' at Castle Pottery). Both establishments turned out two distinct varieties: elegant and often flamboyant shapes, ranging from quite dainty tea services to large items such as jardinières and table centrepieces, usually with painted decoration;

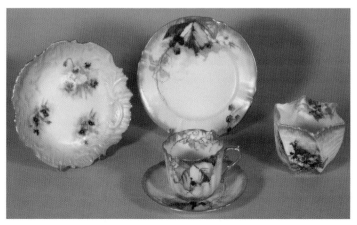

Tea-sets of Nautilus porcelain by McDougall of Glasgow with delicate hand-painted decoration. The central trio (tea plate, cup and saucer) feature brambles, while the dish and the sugar bowl exhibit pansies, though it is their exotic forms which are most eye-catching and invite comparison with Sèvres porcelain.

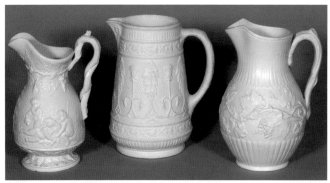

Left: Three jugs of parian ware (unglazed porcelain, intended to simulate the renowned parian marble of antiquity) by Bell of Glasgow. Most unusually for a moulded design, the first one has a name – 'Vintage', with scenes of putti (in Renaissance art, young naked boys) gathering grapes. Note also the vine-twist handle, which develops into a heavily laden vine with leaves, tendrils and bunches of grapes.

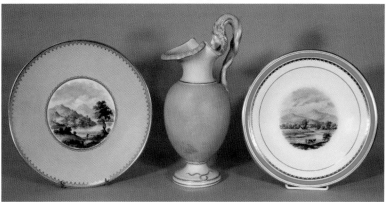

Three pieces of fine bone china by J. & M. P. Bell of Glasgow. The tazza (on the left) and the comport (on the right) both have delicately painted Highland scenes – occasionally these are identified, but not these two examples. In the centre is a most elegant vase, a registered design of 1862.

and a wide variety of Goss-type miniatures, so beloved of Victorian tourists, bearing the arms and mottoes of a great many Scottish burghs and a few English ones as well.

Scaled-down statuary and classical-style jugs were made of parian (unglazed porcelain simulating white marble) by Bell's Glasgow Pottery. Bell also excelled in the production of fine bone china, often embellished with polychrome painting, enamelling

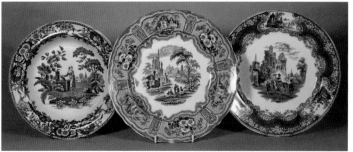

Three transfer-printed plates in the ever-popular 'blue and white' (blue-printed white earthenware): 'The Font' by Rathbone of Portobello Pottery, 'Syria' by Cochran of the Verreville Pottery, Glasgow (almost as popular as 'Willow'), and 'Hawking' by Bell of Glasgow.

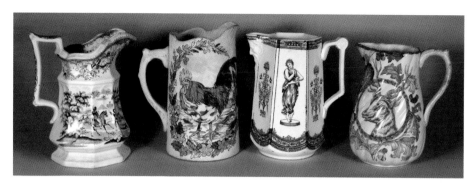

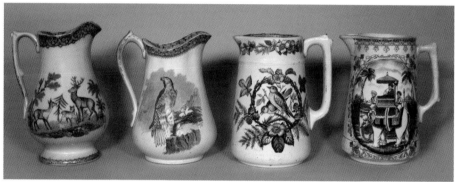

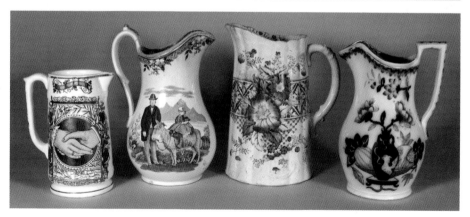

Jugs, jugs, jugs … made in vast numbers by many potteries in Scotland, and decorated with hundreds of different patterns. Top row: 'Falconry' by Jamieson of Bo'ness Pottery; 'Rooster' by Bell of Glasgow; 'Canova' (with a satyr-mask spout) also by Bell; and 'Stag' by Campbellfield Pottery, Glasgow. Middle row: 'Glencoe' by Lockhart of the Victoria Pottery, Pollockshaws; 'Golden Eagle' also by Lockhart; 'Bramble' by Miller of the North British Pottery, Glasgow; and 'Elephant', again by Lockhart (a popular pattern in Burma on a shape which was exported there in huge amounts). Bottom row: 'Auld Acquaintance' by Cochran of the Britannia Pottery, Glasgow; 'My Pet' by the Clyde Pottery, Greenock (the classic shape of Scottish jug); 'Garland' by Methven of the Links Pottery, Kirkcaldy; and 'Jeddo' by Bell of Glasgow (on a shape registered in 1855 which proved enduringly popular). Only two of the twelve jugs (probably the earliest two) have not been treated with additional hand painting, which is often applied in a somewhat gaudy fashion.

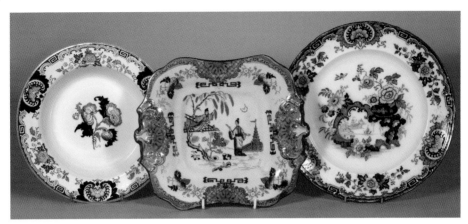

Three transfer-printed plates enhanced by additional hand-painted decoration, by Bell of Glasgow: untitled, the misnamed 'Tamerlane' (featuring a scene from the Chinese dramatic novel 'Romance of the Western Chamber'), and 'Japan'.

and gilding of the highest degree of refinement. China was also made by William Littler at West Pans; also by the Verreville Pottery of John Geddes in Glasgow, and by the adjacent Anderston Pottery, which he ran with partner Robert Kidston.

Other quality types of tableware were also produced. The only place in Scotland known to have made white salt-glazed stoneware was Prestonpans, at the original pottery of William Cadell. Site-recovered sherds indicate such goods to have been mostly elegantly profiled bowls and large platters with relief borders mainly of the 'raised seed' pattern, with some simulated basket-weave and braiding. Although unmarked, they may be distinguished by their stilt marks (usually twelve or fourteen per plate), which are quite different from the rough patches left by the much cruder stilts used by the Staffordshire potteries in the production of similar ware. Cadell also produced other uncommon

Two punch bowls, a popular product, printed with 'Stag' pattern by the Clyde Pottery, Greenock, and 'Lily and Rose' by Bell of Glasgow, enhanced by hand-applied colouring, including fawn lustre.

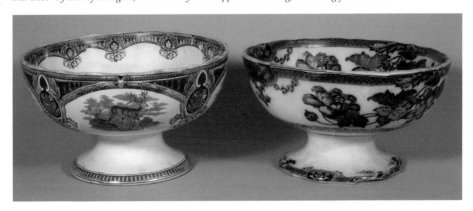

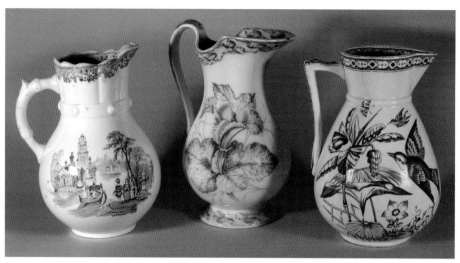

Three ewers printed with (left to right) 'Gondola' by the Clyde Pottery, Greenock, 'Water Melon' by Bell of Glasgow, and 'Brazil', also by Bell. The first one shows features of a prototype made of other materials – a metal handle and a stave-built upper portion held by a riveted iron band.

lines, such as basalt ware.

Creamware was made by William Reid at Musselburgh and Robert Bagnall at West Pans, among others. High-grade earthenware was turned out by a number of firms, who usually gave it special brand names, such as Bell's 'Granite'. These names are sometimes of a dubious nature, for example Clyde Pottery's 'Semi China'; slightly exaggerated, such as the 'Royal Porcelaine' of the Britannia Pottery of Robert Cochran in Glasgow; or inaccurate, like the so-called 'Porcelain Opaque' made

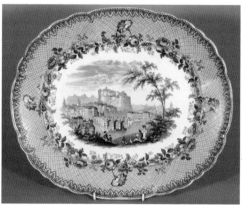

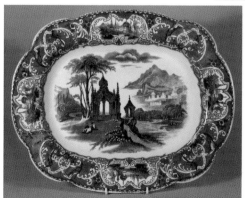

Two blue and white ashets, one (above) printed with 'Edingburgh', an accurate representation (if not spelling) of Scotland's capital city in the eighteenth century, by Kidston of the Verreville Pottery, Glasgow; the other (left) printed with 'Temple', a more robust rendering showing an exotic building set in a dramatic landscape, which appears rather fanciful, by Heron of the Fife Pottery, Kirkcaldy.

by Methven of Kirkcaldy and Jamieson of Bo'ness, which appears to be ordinary earthenware. The accuracy of the descriptions was considered less important than their marketing potential.

The mainstay of the Scottish pottery industry was ordinary serviceable earthenware and stoneware. Dozens of potteries turned out domestic earthenware plates, ashets, jugs, tureens, porridge bowls, punch bowls and the like. The main centres were Glasgow, Bo'ness, Kirkcaldy and Greenock. Decoration was most often by means of transfer printing, involving the use of many hundreds of different patterns, dozens of which were registered with the Patent Office. Some transfer patterns, although not registered, became recognised as virtual trademarks of the potteries which produced them, almost exclusively: *Triumphal Car* by Bell of Glasgow, *Syria* by Verreville (successively Kidston/Cochran/Fleming), *Verona* by Methven of Kirkcaldy and *Bosphorus* from Bo'ness (Jamieson, Marshall, and McNay). On the other hand, the ubiquitous *Willow* pattern was made by at least ten potteries in Scotland.

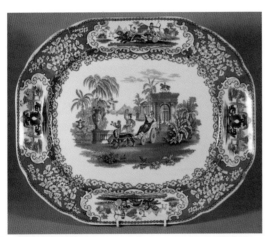

Ashet printed with 'Triumphal Car' pattern by Bell of Glasgow. Several decades before the invention of the automobile, 'car' simply meant a vehicle, and each item of the dinner service exhibited a different type, drawn by a variety of animals – in this case leopards. This pattern became perhaps the most popular among Bell's vast range.

Below: *Three transfer-printed plates by Bell of Glasgow: 'Italian Lakes', 'Moss Rose' and the familiar 'Willow' pattern in an unfamiliar colour.*

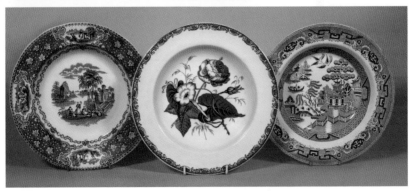

Tureen printed with 'Bosphorus', a hugely popular pattern produced by a succession of potteries at Bo'ness, where sepia was generally preferred to blue.

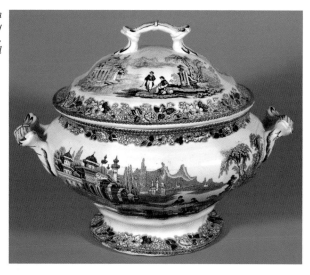

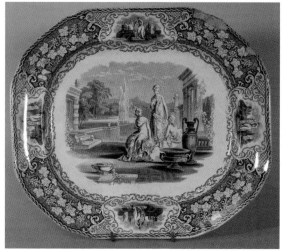

Left: *Ashet printed with 'Verona' pattern by Methven of the Links Pottery, Kirkcaldy. This was their most popular pattern.*

The favourite colour by far for transfer prints was blue, with sepia a distant second; other rarer colours included purple, grey, russet, green and red. Quite often the larger vessels carried additional hand-painted decoration, but all too frequently this amounted merely to blocking in an area of the transfer design, a technique (known as clobbering) which did little to enhance the artistic appearance of the pot.

The other principal method of decorating earthenware was sponge printing, whereby a pattern could be applied repeatedly by means of the root of a marine sponge which had been cut or tied to form the desired shape. Easier and quicker to execute than a

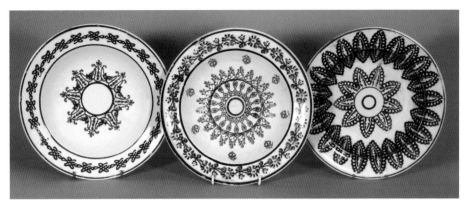

Three sponge-printed plates by Bell of Glasgow; all the motifs are sponged, only the circular lines being painted.

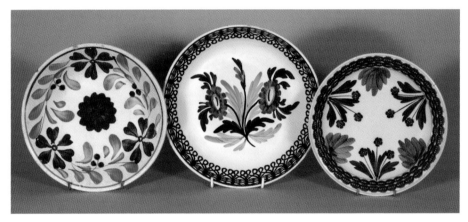

Three painted and sponged dishes, all the motifs being hand-painted with the exception of those in blue, which are sponge-printed; made by (left) Cochran of Verreville Pottery, Glasgow, and (centre and right) Methven of Links Pottery, Kirkcaldy. The middle one is part of a series that received the brand name 'Auld Heather Ware', being intended for export.

transfer print, spongeware was therefore cheaper to produce and what it lacked in elegance it made up for in homely charm. Many of the larger transfer-ware factories also produced spongeware, one of the foremost being the Links Pottery of David Methven in Kirkcaldy. Although made in several other countries, spongeware gained the reputation of being a particularly Scottish product.

The other great mass-produced medium was stoneware, which was used for a wide variety of utilitarian items. Whisky flagons, with capacities ranging from a half-pint (about a quarter of a litre) to 7 gallons (almost 32 litres), were one of the principal lines of production. In addition, all manner of useful goods was made, such as barrels, bread safes, preserve jars, butter jars, meal jars, tobacco jars, whisky jars, cream jars, extract jars, bottles for ginger beer and oatmeal stout, polish bottles, blacking bottles, ink bottles,

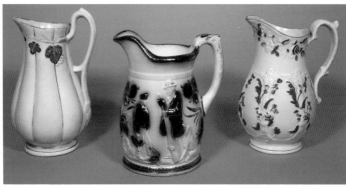

Three relief-moulded jugs; the outer two by Methven of Kirkcaldy, and the central one by Bell of Glasgow, which is enhanced by flow-blue and purple lustre decoration.

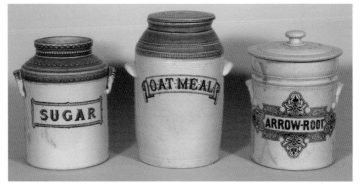

Three stoneware food containers bearing transfer-printed labels indicating the commodity within, by (left to right) Gray of Portobello, Buchan of Portobello and Grosvenor of the Eagle Pottery, Glasgow.

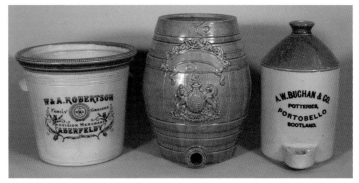

Three large stoneware items: the outer ones are a grocer's butter crock and a cider jar, both by Buchan of Portobello, the latter emblazoned with possibly the largest mark in Scottish pottery, being 5 inches (12.7 cm) wide; in the centre is a cask by Murray of the Caledonian Pottery, Glasgow, which has been made in imitation of a wooden one, representing vertical wooden staves with pronounced graining and horizontal iron bands held in place by rivets.

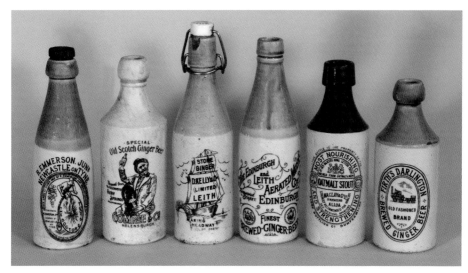

A small selection of the countless millions of stoneware bottles produced by a dozen or so potteries, the majority bearing transfer-printed labels, often incorporating illustrations, which related to the purveyors of the beverages they contained – this was most commonly ginger beer, though alcoholic drinks also featured on occasions.

Five stoneware hot-water bottles, a category of household item where the Scottish potteries proved highly inventive. They are (left to right): the 'Easo Phild' by Buchan of Portobello, patented in 1909; the 'Govancroft Footwarmer', patented in 1929; 'Buchan's Bedwarmer', a registered design of 1913; the 'Possil Warmer' by the Possil Pottery, Glasgow; and 'Buchan's Blue Bottle', so called because of its unusually coloured top.

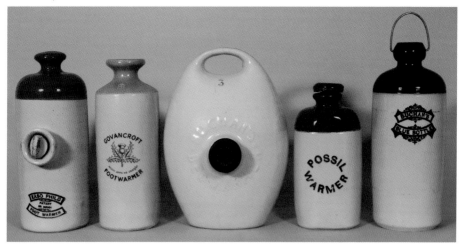

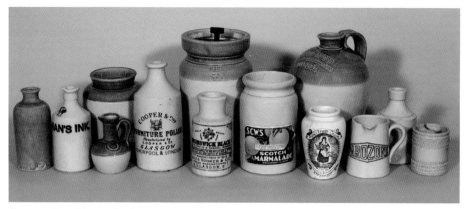

A range of small items of utilitarian stoneware made by a dozen different potteries; they are (left to right): mercury bottle, ink bottle, storage jar, miniature whisky jar, polish jar, ginger jar, blacking bottle, jam jar, small whisky flagon, cream jar, chemical measuring jug, rennet jar, and textured extract pot.

rennet jars, miniature whisky flagons, cream jugs, *soor dook* jugs (for buttermilk), spittoons, vases, hot-water bottles and water filters.

The colossal output of the stoneware potteries emanated almost entirely from two places: Portobello (Buchan and Gray) and Glasgow (Grosvenor of Bridgeton, Kennedy of Barrowfield, Murray of the Caledonian, Miller of Port-Dundas, Buchanan of Govancroft, and a few other smaller concerns). Scottish stoneware potters were very inventive, and dozens of patents were taken out for machines which prepared the clay and formed the pots, and for the pots themselves. Although most stoneware products were intended to be purely functional, they were generally made not only with skill but with grace and charm as well, and some could even be classed as art pottery.

All this while, the old tradition of making red-bodied earthenware lingered on, even thriving in some places. Glasgow supported several redware potteries after the advent of the factory system. The original potteries at Portobello moved to white earthenware, then to stoneware, but just across the Figgate Burn the Westbank and Rosebank potteries continued producing redware well into the twentieth century. The principal producer of redware in the twentieth century, mostly unglazed, was Seaton Pottery in Aberdeen, under Arthur Mills and his son Ivor, who ran the works successively from 1905 until 1964.

In addition to the redware potteries there were many brick and tile works, often in the more remote rural areas, which also made vessels on an irregular basis. Some did so as a matter of course: these may be properly regarded as potteries and would sometimes style themselves as such, as with Megginch Pottery near Errol in Perthshire. For most of these works, however, pot-making was a secondary occupation, and there are indications that it was a seasonal activity, practised only when dictated by demand and the availability of labour.

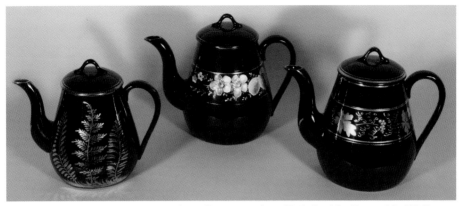

Three teapots of jetware (earthenware with an all-over very glossy black glaze) by Heron of the Fife Pottery, Kirkcaldy, called 'Rosslyn Jet', with overglaze decoration – gilding, enamelling, and both.

Occasionally redware appears in disguised forms such as jetware, which has an all-over covering of glossy black glaze and can usually be identified only if the piece has been chipped or the stilt marks are uncommonly penetrating. An example of Scottish jetware is the 'Rosslyn Jet' of Kirkcaldy *(not* made by the Rosslyn Pottery, which turned out 'Rosslyn Ware', but by the nearby Fife Pottery of Robert Heron). It is quite often gilded or enamelled, or both, techniques also employed by Bailey of Alloa with considerable skill.

Many pieces of redware are treated with white slip. Where the slip is applied in lines it is termed slip trailing, as exemplified on the herring dishes of Dryleys Pottery near Montrose. Often, however, an item is partially coated by the white slip so that it covers a considerable area. In jars it is confined to the interior and mostly out of sight, but with more open items like dairy bowls

Baking dish with slip-trailed decoration, attributed to Dryleys Pottery near Montrose.

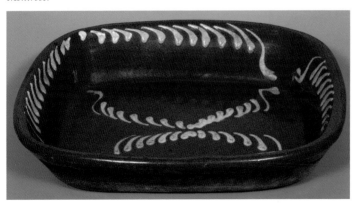

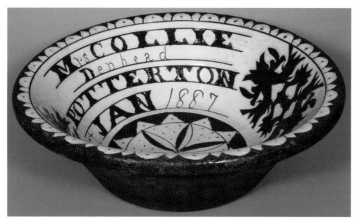

Large dairy bowl with sgraffito decoration – personalised, provenanced and dated; attributed to the Seaton Pottery, Aberdeen.

there was the opportunity to cut through the slip and reveal the reddish body beneath (a technique known as sgraffito), for both decorative purposes and the adding of inscriptions. Fine examples of such bowls were produced by the Seaton Pottery in Aberdeen.

The principal practitioner of the sgraffito technique in Scotland was the Cumnock Pottery in Ayrshire, which turned out a wide variety of domestic goods bearing this form of embellishment. Usually the inscriptions comprised couthie Scots sayings, and such items found a ready market both at home and overseas. Teapots were produced in quantity, and they were often personalised by adding a woman's name and place of residence, and sometimes a date as well. In place of mottoes, lines of verse were occasionally

Motto ware in the Scots vernacular dialect, a speciality of the Cumnock Pottery, Ayrshire, using the sgraffito technique. If read in the sequence in which they have been placed here, a moral edict may emerge – the beer jug hints at over-indulgence, the tumbler suggests caution, while the milk jug advocates a safer beverage which comes 'straight from the cow'!

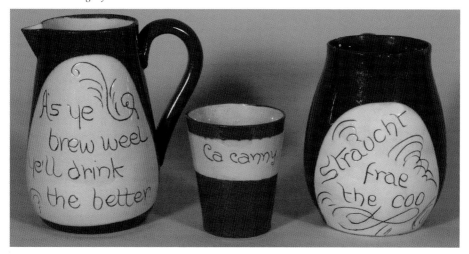

quoted, a favourite being the Selkirk Grace by Robert Burns. Although the slip was generally white (turned cream when fired under a transparent glaze), pastel colours such as blue and green were occasionally used. The other Scottish producer of sgraffito motto ware was Shearer of Glasgow, or so the impressed mark would suggest. However, it appears that Hugh Shearer was no more than a purveyor of novelty goods and documentary evidence points to the actual maker being Bailey of Alloa.

Completing the full range of ceramic production which began with delicate porcelain was heavy-duty fireclay ware. Scotland contained a number of fireclay works, the majority being located in the industrial region of the west. The foremost of these was run by the Garnkirk Coal Company near Glasgow, where a wide range of goods was produced. Most were purely functional, but they also made ornamental chimney cans, statuary, tiered fountains that extended to $11^1/2$ feet (3.5 metres) in height, and huge replicas of famous objects such as the Warwick Vase and the Florence Vase. There were similar works in the east at Kirkcaldy, Dunfermline and Inverkeithing, all in Fife. Terracotta statuary was made at Grangemouth.

Some of the fireclay factories also produced white-enamelled sanitary wares. The leader in this field was the Victorian Pottery of Douglas Shanks at Barrhead in Renfrewshire, which specialised in fitting out large passenger liners built in Scotland and elsewhere. Clay tobacco pipes were produced in millions by such firms as Christie of Leith and McDougall of Glasgow.

As production increased and diversified, so the pottery industry

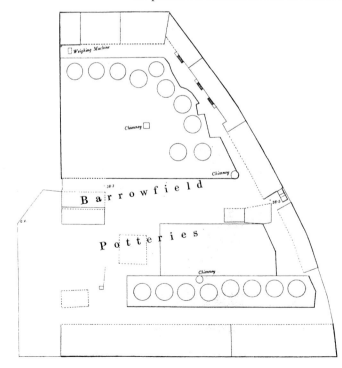

Plan of the Barrowfield Pottery of Henry Kennedy, Glasgow, from an Ordnance Survey map of 1893. It depicts eighteen kilns in two banks, the largest number known to belong to any Scottish pottery.

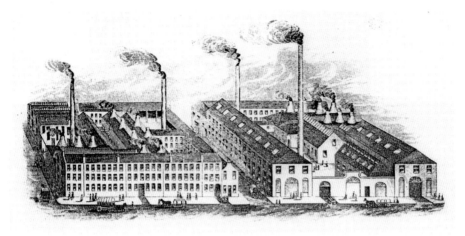

Engraving of Port-Dundas Pottery, Glasgow, intended for the cover of a trade catalogue, showing seventeen kilns and four very tall chimneys. This made it one of the largest potteries in Glasgow, though the extension (on the right) operated only for a few years in the mid 1890s.

spread to many parts of Scotland. Glasgow remained the principal centre, with more than fifty potteries known to have existed in the city at various times. Such works as those of Bell (Glasgow Pottery) and Cochran then Fleming (Britannia Pottery) produced vast quantities of earthenware on a scale that even the larger companies in Staffordshire were hard pushed to match.

The major Glasgow stoneware factories, such as those run by Henry Kennedy (Barrowfield Pottery) and Frederic Grosvenor (Eagle Pottery), were equally prolific in their output. Another leading stoneware maker, the Port-Dundas Pottery, devoted a

Three tobacco/snuff jars: (left) with a man smoking a 'cutty' (a short-stemmed pipe) with smoke issuing from the bowl, by Buchan of Portobello; (right) with a woman holding a snuff-box, in the act of 'sneeshing' (taking snuff), by Murray of the Caledonian Pottery, Glasgow; and (centre) a jar without a figure, bearing a very heavy collar, by Grosvenor of the Eagle Pottery, Glasgow.

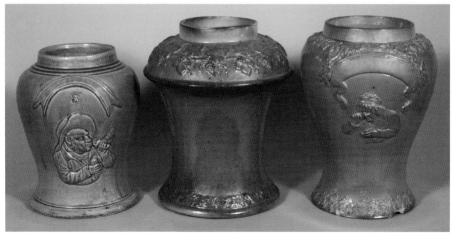

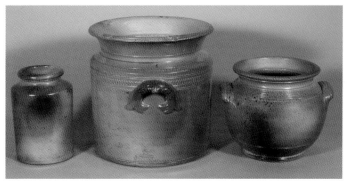

Three differently shaped jars of salt-glazed stoneware. The outer two, attributed to Milne & Cornwall of Portobello, show interesting firing blemishes, a hazard of this technique; the central jar is by the Port-Dundas Pottery, Glasgow.

greater proportion of its production to the salt-glazed variety than did its fellows, and it was the most adventurous in this field. Most aspects of the ceramic industry were represented in Glasgow, including exotic lines such as vermicule-encrusted pearlware by Delftfield Pottery, polychrome agate and marbled ware by Britannia Pottery and impasto stoneware by the Port-Dundas Pottery.

The other principal area was the Forth region, consisting of a string of towns situated by the river Forth and on either side of its estuary. Activity in East Lothian tended to fade, though Prestonpans remained important through the potteries of Gordon,

Two pairs of useful stoneware items: a jar by Grosvenor of the Eagle Pottery in Glasgow (a registered design of 1885) and a bottle by Gray of the Midlothian Pottery in Portobello (a registered design of 1912), each having a textured body to help prevent the object slipping from the hand; and two cemetery flower vases (inverted) by Buchan of Portobello, the style being known as 'Portovase' (the straight-sided one patented in 1922, and the round one with the screw thread registered and then patented in 1925).

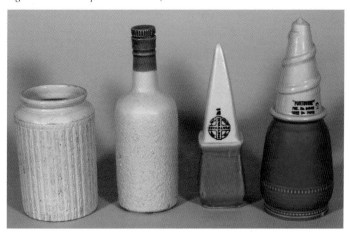

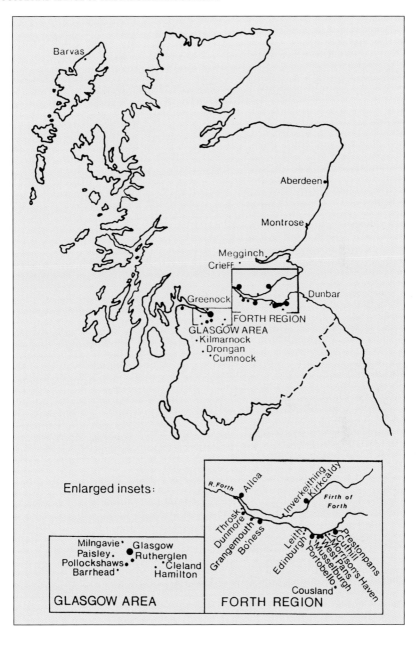

Map showing the distribution of the Scottish potteries of the industrial era. Pottery-making centres of major importance are denoted by a large dot, those of moderate importance by a medium-sized dot, and those of lesser importance by a small dot. This rating has been based on such factors as the number and longevity of the potteries and the volume and distinctiveness of their products. It is nevertheless only a notional assessment.

Two somewhat quirky drinking devices for poultry, one by Buchan of Portobello (a clever contrivance patented in 1896), the other by Grosvenor of the Eagle Pottery in Glasgow (an elaborate registered design of 1882).

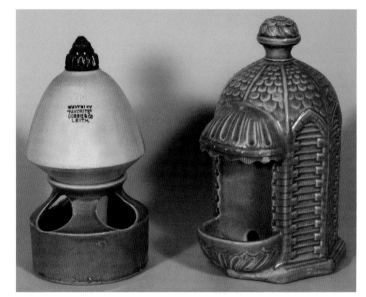

Watson and latterly Belfield. Just east of Edinburgh, Portobello became a major centre, the elegant earthenware of the Rathbone family giving way to the great stoneware potteries of Buchan and Gray. The capital, not noted for its industry, supported the little Holyrood Pottery, remarkable for its mottled leadless glazes.

To the west of Edinburgh, Bo'ness, in conjunction with its satellite communities of Bridgeness and Grangepans, was an important centre. It lasted longer than most, for McNay was in

A group of items of the celebrated Wemyss Ware by Heron of the Fife Pottery, Kirkcaldy, illustrative of the three main phases of production: a jug from the early period, when the shape was the governing factor; a huge three-handled loving cup and a tiny jam pot typical of the Nekola decorating school at the height of its prowess; and a vase with a distinctive scalloped rim (known as the Lady Eva vase, she being a member of the local noble family of Wemyss, who gave their name to the whole range) carrying flamboyant 'jazz age' decoration, a variant of the Nekola artistry which replaced the white background with areas of strident colouring.

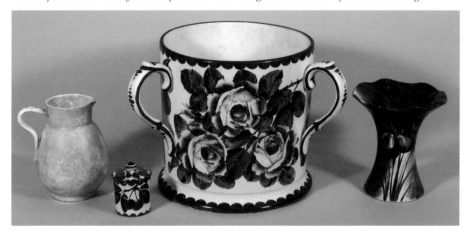

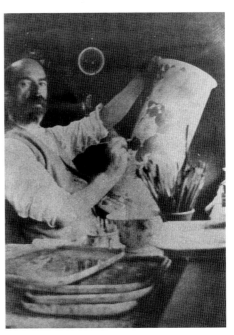

Karel Nekola, the most famous decorator of Scottish pottery, in his studio, 1913. A native of Bohemia, he was brought to Kirkcaldy in about 1883 by Robert Heron, proprietor of the Fife Pottery, to become head of the decorating shop. Painting natural subjects in vivid colours, his superb artistry made Heron's Wemyss Ware desirable in its own day, and avidly collected now.

production until 1958. On the other side of the Firth of Forth, Kirkcaldy was a renowned centre with at least four potteries, including the large factories of David Methven (Links Pottery) and Robert Heron (Fife Pottery), the latter famed for its colourful hand-painted Wemyss Ware. Up the River Forth at Alloa, W. & J. A. Bailey made millions of brown teapots in a variety of styles, while Peter Gardner of Dunmore was celebrated for his exotic shapes and glazes, being patronised by royalty and nobility.

Other potteries in the west were situated at Pollockshaws, where David Lockhart's Victoria Pottery was in production from 1855 to 1952; Rutherglen, whither Murray's Caledonian Pottery moved on leaving Glasgow; and Greenock, where the Clyde Pottery is one of the few to have received detailed site investigation.

Modern research is broadening the pottery map of Scotland, the most noted addition being Aberdeen. At least four potteries existed there, the main one being the Seaton Pottery. Under Thomas Gavin

Dabware attributed to Gavin of the Seaton Pottery, Aberdeen, on the basis of the distinctive forms of the capital letters and some numerals, especially eights. Reserves containing personal names sometimes included messages and mottoes, and they were generally dated.

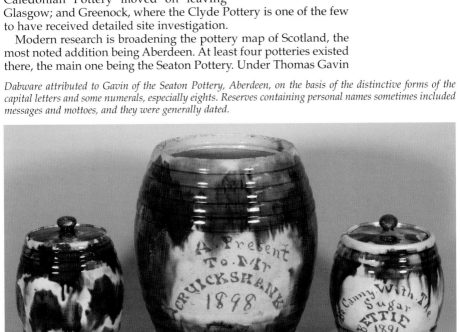

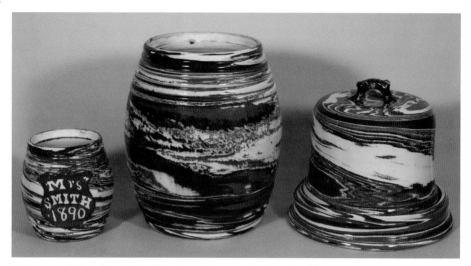

Agate ware attributed to Gavin of the Seaton Pottery, Aberdeen (see dabware caption, page 33). Wedging together light and dark brown clay with white clay, and dividing the resultant lump into single balls before throwing, produced a dramatic effect which sometimes resembled natural agate stone.

and his son John it produced a striking line in both dabbed ware and agate ware, many pieces being embellished with dates, personal names and messages by means of a clay inlay technique. Seaton agate ware is among the most spectacular of all ceramic creations. The short-lived Clarke & Smith phase saw the production of elegant vases, while during the lengthy Mills period Arthur and his son Ivor specialised in horticultural wares. Less likely towns known to have had potteries include Montrose, Kilmarnock, Inverkeithing, Drongan and Cleland.

Even Barvas on the island of Lewis may be included, best-known producer of the notorious croggan ware (from the Gaelic *croccan chriadh*, meaning 'clay pot'), which was made at various places in the Western Isles. This primitive ware was hand-made without the wheel, glazed with nothing more than milk and fired in a clamp kiln of turf and seaweed. It provides the intriguing possibility of a continuous tradition of pottery making in the Hebrides stretching from the late Bronze Age into the twentieth century. It existed apart from the mainstream of pottery production, indicating the differential nature of progress even in a small country like Scotland.

Scottish pottery exports

The great boom in the Scottish pottery industry occurred when men of vision realised that there was a potential market for their wares far beyond the bounds of their homeland. Whether the potteries responded to an existing need or whether they sought a solution to an excess of productivity is difficult to assess. What is certain is that for much of the industrial period the output of the Scottish potteries greatly exceeded the quantity which could be assimilated by the domestic market. The result was a huge and varied output, much of it destined for export.

The strength of Scotland's export trade in pottery had a sound footing, for two of the earliest factory owners participated with vigour. The Delftfield Pottery was run by a consortium which included Laurence Dinwoodie, a considerable presence in the mercantile life of Glasgow and a former Lord Provost of the city, and his brother Robert, who served as Lieutenant-Governor of Virginia between 1751 and 1758 (Delftfield being founded in 1748). It is highly likely that Robert Dinwoodie encouraged the importation of Glasgow delftware into Virginia during his term of office. There is evidence to bear this out; for instance, the customs accounts of Port Glasgow during the first decade of the pottery's production show that of the fifty-seven sailings of ships which included pottery among their cargoes thirty-one had Virginia as their destination.

The other important figure in the early days of pottery exports was William Cadell, who founded the first pottery in Prestonpans in 1750. He was an entrepreneur who dealt with the import and export of a wide range of commodities, pottery included. For commercial reasons, it is likely that most of Cadell's wares were shipped out through Leith, and, although the customs accounts seldom specify the origin of the pottery being exported, they do reveal that in the period 1750–92 Scottish pottery (probably most of it from Prestonpans) was exported to no fewer than fifty-three ports around the world. Although the quantities were seldom large, the remarkable spread of this foreign trade must have been very encouraging to the growing industry.

Other potteries followed suit. Before the end of the eighteenth century, William Creelman of Coats Pottery in Lanarkshire was exporting salt-glazed bellarmine jars to the United States of America and the West Indies. Thomas Rathbone of Portobello advertised on a billhead in 1825 that his goods were 'for Home and Exportation'. The mighty Bell factory, probably Scotland's most prolific exporting pottery, issued a circular almost as soon as it went into production in 1842 declaring that its wares were 'for home sale and exportation'.

The wide and varied range of export goods included the 'white granite' wares of Britannia Pottery, which had an exceptionally tough ironstone body designed to withstand the rough prairie tracks of the western United States; a variant with a beaver in the

border was aimed at Canada, and Cochran also produced transfer-printed Canadian scenes for a retailer in Quebec. Other export lines were the African motto ware of Alexander Balfour's North British Pottery, the language having been identified as Yoruba, spoken in south-west Nigeria; and mulberry-tinted tea services by John Thomson of Annfield Pottery, which were sent in large numbers to Australia.

These potteries were all in Glasgow, well placed for shipping abroad, but factories in the east also exported, as indicated by an advertisement in *The Pottery Gazette* in 1896 for John Marshall of the Bo'ness Pottery: 'Sponged goods for home and all foreign markets. Special lines for the Colonies.' One of these special lines was probably a series of designs produced by Marshall entitled *Canadian Sports*. They included figure skating, tobogganing, sleigh riding and snow shoeing, eagerly enjoyed by both sexes, the sources being Canadian greetings cards celebrating Christmas and the New Year. Bailey of Alloa produced teapots bearing the Australian coat of arms.

While contemporary accounts of Scottish pottery production are not common, there are a number which concentrate specifically on the export trade, a measure of the importance in which it was held. *The Scotsman* described goods awaiting dispatch from J. & M. P. Bell's Glasgow Pottery in 1868 as follows: 'The vast warerooms of the establishment contain hundreds of thousands of articles of every conceivable form and colour, designed to meet the taste of customers in various quarters of the world. Side by side may be seen piles of hard and very white granite ware of a severely plain style, and common cream-coloured wares covered with the most outrageous designs in the gaudiest of colours. The one is the choice of the United States, and the other finds purchasers in the East and West Indian markets.'

Bell's oriental trade was one of the most interesting of the various export drives conducted by several Scottish potteries in the later nineteenth century. They developed a staggering range of patterns aimed specifically at south-east Asia, of which fifty were especially designed for and/or exported in large numbers to the East Indies, and many others in lesser amounts. This truly astonishing series of patterns featured a bewildering array of complex geometrical designs, exotic fruits, fearsome dragons, and mythical creatures of land, sea and air. A total of thirty patterns was registered with the Patent Office (actually twenty-nine, as one pattern was given two different borders), dating between 1887 and 1906. Many of the pattern names appear in the Malay language, and in several cases the name is repeated in Malay Arabic script (see page 61). Other patterns were given place-names, most belonging to the East Indies, though the distribution of these patterns is fairly evenly spread throughout the archipelago.

The plates that carry these extraordinary designs were printed in a range of colours, not all of which were common by domestic standards, but the most surprising feature of the printing is that often the central design and the border were done in two different

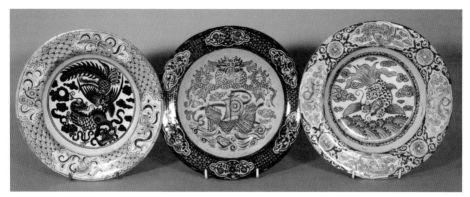

Three transfer-printed plates by Bell of Glasgow produced for export to the East Indies; a dual-colour printing, extremely rare on the domestic market, was the norm for this trade. The outer two designs were based on Chinese ceramic art: (left) 'Keelin Hong' features two mythical creatures, the qilin and the phoenix, which were regarded as highly auspicious, making this the most popular pattern in the series; and (right) 'Ikan China', showing a carp transmogrifying into a dragon as it leaps the Lung Men falls. (Centre) 'Kapal Basar' (Malay for 'big ship') illustrates a sixteenth-century Portugese caravel. These patterns were all registered – in 1889, 1891 and 1889 (from left to right).

colours – a technique almost unheard of on wares for the home market. Bell's also produced gaudy spongeware for the East Indies, but perhaps no pottery anywhere, at any time, can match the ultra-gaudy painted plates with sponge-printed borders which they made for the Iban people of south-west Borneo. Although the bulk of Bell's exports appear to have been deep plates, there were also some special items, such as shallow dishes of large size, up to 15 inches (38 cm) in diameter, for holding conical mounds of rice at ceremonial banquets.

A number of other Scottish potteries also contributed to the East Indies market, notably Robert Cochran & Co of the Britannia Pottery, two-colour prints being included among their export

Three plates by Bell of Glasgow bearing exceptionally gaudy decoration, mostly hand-painted with sponge-printed borders. These were made in considerable quantities especially (and perhaps exclusively) for the Iban tribes of south-west Borneo, from whom these pieces were obtained.

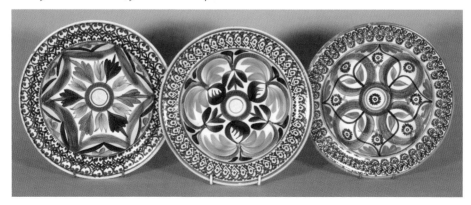

wares. David Methven & Sons of Kirkcaldy exported a less exciting
range of patterns there, but at least four of them bore a motto (on
the underside) in the Javanese Jawi script (see page 61).

Another country to receive huge quantities of Scottish pottery
was Burma. Again Bell's were well to the fore, John Bell having
established a commercial base at Dunnidaw in Rangoon. They
produced seven registered designs specially for Burma, dating
between 1889 and 1907; Cochran of Verreville also did one, in 1897.
Jugs were sent in vast numbers by David Lockhart of the Victoria
Pottery in Pollockshaws, Charles McNay of Bo'ness, and others. A
large amount of multi-coloured sponge-printed ware was also
shipped to Burma, basins for the most part, but the principal
speciality was flow blue, with basins, bowls and plates painted and
sometimes sponged with a vivid royal blue which flowed during
firing to produce a most striking effect. A number of potteries made
these items, chiefly Cochran of Glasgow (Verreville) and Methven
of Kirkcaldy.

The fame of Scottish potteries was enhanced by their success at
several of the international exhibitions that were popular in many
countries in the later nineteenth century. For instance, there were
medals for the Port-Dundas Pottery at Santiago, Chile, in 1875; for
Bailey of Alloa at Philadelphia, USA, in 1876; for both Buchan and
Gray of Portobello, and for Gardner of Dunmore, at Edinburgh in
1886; and for Methven of Kirkcaldy at Paris in 1896. Bailey claimed
its Rockingham teapots to be the finest in the world and exported
them to many countries. To cater for demand, they kept 100,000
teapots in stock at all times, which was reputedly less than one

Two examples of 'Burmese Blue', a deep royal flow blue which frequently left almost no white fabric visible, produced predominantly for the export market in Burma; (left) a basin by Cochran of the Verreville Pottery, Glasgow, and (right) a deep plate with an elephant in the centre by Methven of the Links Pottery, Kirkcaldy.

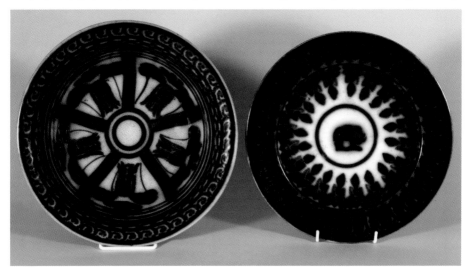

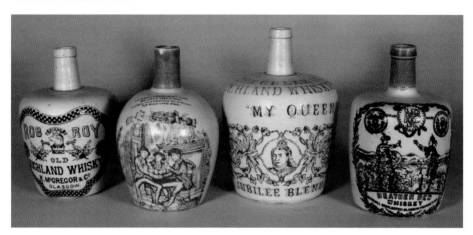

Stoneware whisky jars, a mainstay of a number of Scottish potteries, large quantities being produced for export – along with their contents! This quartet relates to 'Rob Roy' (a revered eighteenth-century outlaw belonging to the Clan MacGregor), by the Port-Dundas Pottery, Glasgow, the leaders in this field; 'Auld Lang Syne' (a celebrated eighteenth-century song penned by Robert Burns, the convivial tavern scene coming from an edition of his poetical works published in 1842) which was registered in 1882, by Kennedy of the Barrowfield Pottery, Glasgow – both these jars sent to Java; 'My Queen Jubilee Blend' (commemorating Victoria's Golden Jubilee in 1887), by the Port-Dundas Pottery – sent to Burma; and 'Heather Dew' (the whole scene registered as a trademark in 1880), which was made by half a dozen potteries in Glasgow and Portobello.

month's production. Belfield of Prestonpans produced Rocking-ham teapots (a Scottish speciality) for a customer in Valparaiso, Chile. Thus the fame of Scottish pottery spread throughout the world.

There are several ways in which the extent of the export trade may be gauged. Documentary evidence, such as shipping records, can be quite revealing. Large quantities of particular lines of pottery found in certain countries can provide interesting pointers; more reliable are the actual patterns, the nature of which is often so alien to European taste that it is reasonable to assume that they were made specifically for the far-distant countries where they may now be found. Most telling of all can be the maker's marks, which sometimes include pattern names in foreign languages and may even be written in non-roman scripts (see page 61).

While most exports were aimed at the native market of the country of destination, some seem to have been made for emigrant Scots. Perhaps the best-loved and most widely distributed class of such items was the Cumnock motto ware with its variety of couthie sayings. These must have warmed the hearts of expatriate Scots around the world.

Social aspects of industrialisation

With the coming of the factory system a great many more people were engaged in pottery making than previously. Initially there was a considerable English influence, and workers from Staffordshire and Derbyshire were employed by potteries in Glasgow, Prestonpans, Portobello, Kirkcaldy, Bo'ness, Montrose and Aberdeen.

In the early days of the industry it was not uncommon for the proprietors of Scottish potworks to retail their own wares supplemented by Staffordshire imports for which they acted as agents. There may well have been sound practical reasons for this, such as widening the range of ware on offer and not being totally dependent upon unproven techniques, yet it must have created ambivalence towards what should have been a direct rival. Moreover, there were some dealers who handled only Staffordshire wares and who must have viewed the growth of the industry in Scotland with hostility. Even so, one such trader, writing in 1796, was forced to concede: 'It must be observed that the Manufacturers, particularly in Scotland, have made such rapid strides in

The potbank in the Britannia Pottery, Glasgow, c.1900. Nine kilns are visible, giving an indication of the colossal output of one of the largest industrial concerns in Scotland when at the height of its productivity.

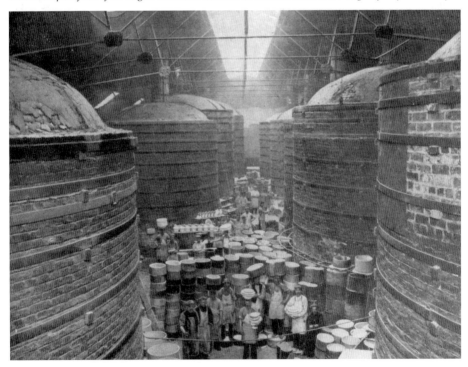

Setting a kiln, Buchan's Pottery, Portobello, 1948. The stacking of a kiln with saggers (fireclay containers holding the ware to be fired) was a skilled job; it also required strong neck muscles and a keen sense of poise on the part of the stacker's assistant.

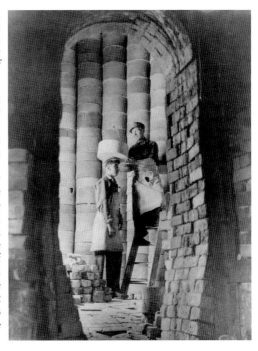

improvement, that many of them actually make as good Cream Colour as is generally made in Staffordshire; their sizes are so much larger in proportion as of a Scotch 3 to a Staffordshire 2.'

As the Scottish pottery industry developed in stature and confidence there was less need to rely on the expertise of foreign craftsmen and indeed the movement of labour began to swing in the opposite direction. The prime example was the introduction of spongeware to Staffordshire around 1845 at the Greenfield Pottery. The proprietor, William Adams, found that it was necessary to procure workers from Scotland who understood the process.

A thrower at the wheel, Buchan's Pottery, Portobello, 1966. He is producing whisky jars (probably for export) in some quantity. To ensure that they are made to a standard height and width, two gauges are fixed to a stanchion beside the wheel. His assistant, known as a bencher, is seen wedging the clay (kneading it to expel any air pockets), after which he weighs each lump to ensure that the vessels will have a standard capacity, and forms it into a ball ready for throwing on the wheel. This procedure greatly speeds up the production rate of the potter.

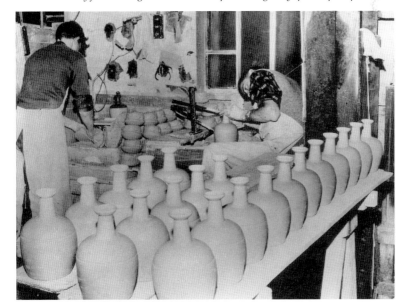

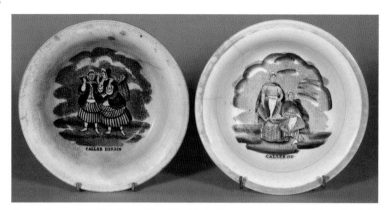

A pair of bowls, in which the quality of the fabric, the engraved prints and the painted decoration (clobbering) all indicate that they were made for the bottom end of the market. Nevertheless, they were popular with fishing communities and show fisherwives (perhaps from Newhaven) with full creels. The captions echo the calls of these street sellers: 'Caller Herrin' (fresh herring) and 'Caller Ou' (fresh oysters). Attributed to Methven's Pottery, Kirkcaldy.

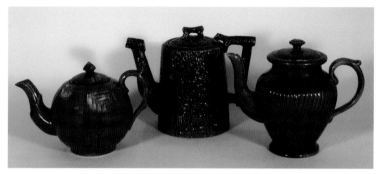

Three Rockingham-glazed teapots, all made according to registered designs, by (left to right) Bailey of Alloa Pottery (key pattern, 1867), Murray of the Caledonian Pottery, Rutherglen (rustic, 1877) and Belfield of Prestonpans Pottery (spiral reeding, 1883).

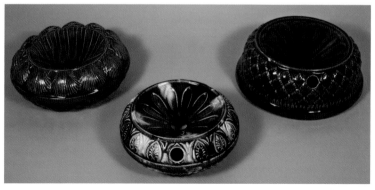

Three spittoons, by Murray of the Caledonian Pottery, Glasgow (scallop design), Belfield of Prestonpans (anthemion design), and Grosvenor of the Eagle Pottery, Glasgow.

It was not only techniques that were exported, but also the enterprise required to start a new pottery. From Glasgow, George Guthrie of the Port-Dundas Pottery went to Australia in 1858 and founded the Bendigo Pottery (which still thrives), and William McAdam of the Hydepark Pottery emigrated to New Zealand in 1879, aged seventy-one, reportedly to start a pottery at Dunedin.

Considerable capital was required both to establish and to run a pottery, and sequestrations and litigations dogged many a pottery owner's endeavours. The former can illustrate a pottery's requirements in order to function; the latter can reveal much about working practices. Lawsuits were heard concerning such aspects of the business as disastrous initial firings (Delftfield Pottery, Glasgow, 1748–9), the mobility of labour (West Pans and Bo'ness Potteries, 1794), rates of pay for skilled specialist work (Gordon's Pottery, Prestonpans, 1831) and for new work (Links Pottery, Kirkcaldy, 1893).

Litigation was not the only form of trouble in which potters could find themselves. In 1805 Hugh Adamson and David Scott, a potter and engraver respectively at the Glasgow Pottery (later known as the Caledonian Pottery), were hanged at Glasgow Cross for forging notes of the Ship Bank. At least this illustrates the high standard of engraving at the Pottery. It was not only the rascally potters who suffered at the hands of the community, but potters in general seem to have come in for rough treatment at times. For instance, Kirkcaldy town council passed a bylaw in 1897 imposing a 40 shilling (£2) fine on potters (and several other categories of worker) who walked along any footpath wearing clothes that might soil those of another pedestrian.

Potters were also held in low esteem in Bo'ness, though here they were themselves partly to blame. The potters of the town were noted for their alcoholism, caused not only by their off-duty drinking, but also by their habit of smuggling liquor into the works. They were held in such poor regard that unfortunate spinsters were taunted with the saying 'Ye'll just hae tae tak' a potter yet'. Hoping to rid the pottery of this stigma and enhance the standing of its workers, the owner, John Marshall, initiated several schemes for the benefit of his employees: he opened a reading room and a social club, and each summer he organised a works outing for the potters and their families. In a similar spirit Joseph Bailey of Alloa Pottery held annual soirées in the factory for the workers and their friends.

Such philanthropy was not commonplace, however, and sometimes potters banded together to look after their own interests. As early as 1766 the potters of Prestonpans were so organised that they formed a box society. This was a form of friendly society that involved paying an entry fee and a regular subscription into a box which was under the care of a committee. The funds thus accumulated were used to assist members who were suffering financial hardship: they received sickness benefit, retirement pensions, burial grants, and provision was also made for widows and orphans.

Rockingham ware (earthenware with an all-over treacly dark brown glaze): two novelty whisky flasks in the shape of a 'tattie' (potato) and a ladies' boot, possibly by Belfield of Prestonpans; and a penny bank modelled on the head of Souter Johnnie, attributed to Morrison & Crawford of the Rosslyn Pottery, Kirkcaldy.

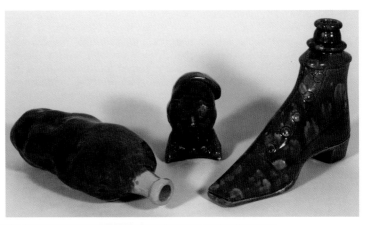

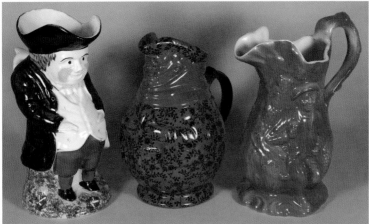

Above: *Three novelty jugs exhibiting three different methods of decoration: Toby jug, attributed to Methven of the Links Pottery, Kirkcaldy – painted, with sponged base; Friar Tuck jug by Marshall of the Bo'ness Pottery – transfer-printed (unnamed pattern registered in 1881); and Tam o'Shanter jug by Methven, with high relief figures of Tam and Souter Johnnie, characters from Robert Burns's most celebrated poem, modelled on life-size effigies sculpted by James Thom, to be seen at the Burns Monument in Alloway (1823) and at Souter Johnnie's Cottage at Kirkoswald, and registered by Methven in 1908 – aerographed.*

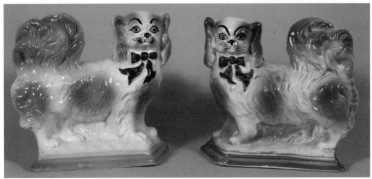

Very popular mantelshelf ornaments – a pair of spaniel dogs, by McNay of the Bridgeness Pottery, Bo'ness (registered design of 1909); aerographed, with painted features.

It became commonplace for potters to serve formal apprenticeships to ensure the proper training of operatives. Gray & Co of the Fife Pottery in Kirkcaldy took on a plate-maker and printer in 1817 on a five-year apprenticeship, requiring him to 'abstain and refrain from all vicious company, gaming, excess in drinking, night walking and debauchery, being an accessory to mobs and tumults, and from every idle exercise that may in any way divert him from his Masters' service'. The Port-Dundas Pottery in Glasgow took on a hollow-ware presser in 1853 on a seven-year apprenticeship 'to teach, learn, and instruct the said apprentice in the hail [whole] points and articles of the said trade in so far as known to or practised by the Masters'. These indentures also stipulated the apprentices' rates of pay, which rose on an annual basis as experience was gained and skills were improved.

As the industry developed, unions were formed for different categories of potters. The early potters' trade unions in Britain were, not surprisingly, based in Staffordshire, though they often encompassed a Scottish element. This is evident both in their names, for example the Amalgamated Society of Hollow-ware Pressers and Clay Potters of the United Kingdom (formed in 1871), and in their constitutions, such as that of the National Order of Potters (formed in 1883), which aimed to cater for all members of the trade in Britain. However, Scottish branches do not seem to have been very effective in their negotiations, and so the Scottish Operative Potters' Federal Union was instituted in 1890. It appealed to 'all Potters who believe in upholding the dignity and prosperity of their labour to join us in this great movement'. In addition, there were separate Scottish unions for certain specialist groups of workers within the industry.

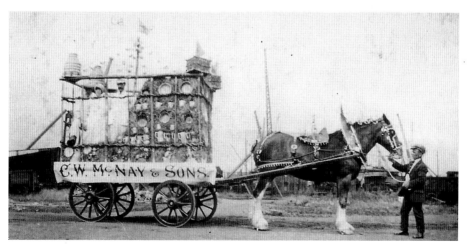

A horse-drawn float turned out by the Bridgeness Pottery of Charles McNay, Bo'ness, c.1930. An impressive display of their products has been arranged for a parade at some local gala event. Jugs and large dishes are strongly featured, and cups are festooned above the framework. Interesting objects have been placed at each top corner of the frame: at the front are a pair of packing crates, and at the rear a pair of model kilns. The framework also accommodates three employees of the Pottery (two men and a woman) dressed in their white working clothes.

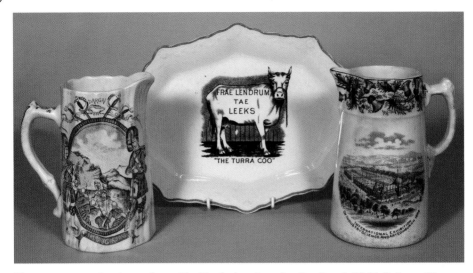

Three commemorative items: jug with 'Gordon' pattern by the Campbellfield Pottery, Glasgow, commemorating the heroic action of the Gordon Highlanders at the Battle of Dargai (1897) on the North-West Frontier of India; ashet featuring the Turra Coo (Turriff Cow), symbol of resistance in north-eastern Scotland to Lloyd George's National Insurance Act of 1913 – possibly by Bo'ness Pottery; jug by Cochran of the Verreville Pottery, Glasgow, commemorating the Edinburgh International Exhibition of 1886, Scotland's first venture into this most exciting field of endeavour.

Robert Burns commemorative pottery: the outer jugs commemorate the centenaries of his birth (1859, by Bell of Glasgow) and death (1896, by Lockhart of Pollockshaws); two other jugs with scenes from 'Tam o' Shanter' (Tam and Souter Johnnie drinking in the tavern, by the Clyde Pottery, Greenock, and the dramatic high point of the poem, attributed to Lockhart); and a mug with another portrait (by McNay of Bridgeness Pottery, Bo'ness).

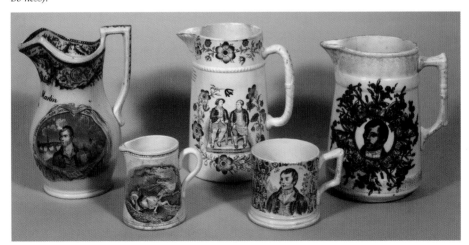

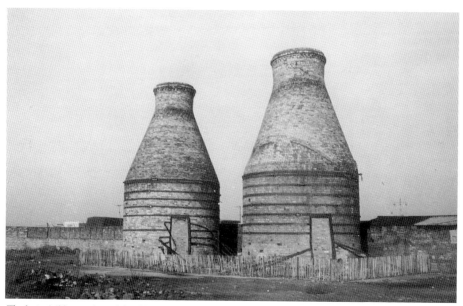

The last visible remains of the old Scottish pottery industry: Buchan's kilns at Portobello. These structures represent the final phase of development at Portobello, being dated 1906 and 1909 (a third, dated 1904, was demolished in 1955 to make way for the introduction of electric kilns). After the pottery closed in 1972, vandals set fire to the factory buildings so that they had to be demolished rather than preserved to house a pottery museum as had been envisaged. The land was then redeveloped without the anticipated archaeological investigation taking place (though some minor ones have been conducted since). This photograph shows the kilns after the factory was demolished but before they were hemmed in by new houses. The loose bonts (iron hoops) were reinstated, but the top half of the 1906 kiln (on the right) was mistakenly taken down, then poorly rebuilt using new bricks. The 1909 kiln suffered heavy vegetation growth, and during vigorous remedial work in 2006, the top half collapsed. The bricks have been saved and a rebuild is planned, but these two bottom halves are now virtually all that remains in the landscape of Scotland as testimony to a once thriving industry.

In towns where the manufacture of pottery was a major industry, the pottery workers demonstrated their importance to the local economy by staging periodic parades or participating in trade processions. This was to be seen in places such as Glasgow, Greenock, Prestonpans and Bo'ness. The last-named town even supported the Bo'ness Industrial Co-operative Pottery Co Ltd, though only for a short time (1891–4).

For a century and a half the Scottish pottery industry expanded and prospered, but its demise was not far distant. There was increasing competition from both Staffordshire and from Europe, and also from other materials such as glass and aluminium. Changing social requirements in fields such as plumbing, lighting and food hygiene rendered certain classes of ware obsolete.

The upheavals of history also played a part. Industry in general was hard hit by the First World War, and foreign markets were lost which were never recovered. Worse was to come with the Depression of the 1920s, which led to a widespread decline

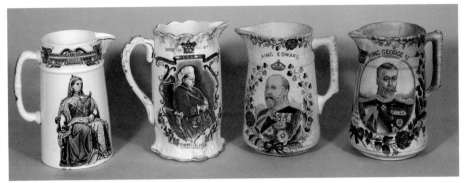

Four royal commemorative jugs celebrating two jubilees and two coronations: Victoria's Golden Jubilee (1887) by the Clyde Pottery, Greenock, and Diamond Jubilee (1897) by the West Lothian Pottery, Bo'ness; and the coronations of Edward VII (1902) and George V (1911), both by Lockhart of the Victoria Pottery, Pollockshaws.

throughout the whole field of manufacturing industries, and pottery production slumped along with the rest.

The potteries suffered grievously as closure followed closure, and very few were able to survive to the middle of the twentieth century. Now all are gone. A final vestige lives on in the name of Buchan of Portobello, though since 1972 production has been carried out at new works at Crieff in Perthshire. Although apparently prospering, the factory was unexpectedly closed down in 1999, but it was not killed off completely. In a corner of the former works, one thrower (Joe Hunter) and one decorator (Kareen Cramb) continue to work away, and the Buchan's thistle trademark, which dates from 1949, has been re-registered. Their determination is being rewarded with a full order book, though this is but a faint echo of a once great industry. Scottish pottery, as an important element of the national economy, is no more.

Another example of motto ware, this time by Dunmore Pottery in Stirlingshire. "Kale brose" is a wholesome Scottish dish composed of colewort soup boiled with meat and mixed with oatmeal. The interior of the coggie exhibits spatter-glaze decoration.

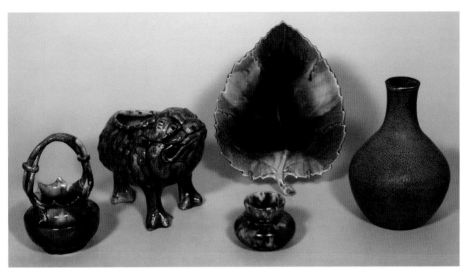

Five examples of the varied output of Dunmore Pottery, which became Scotland's leading exponent of the Arts and Crafts movement under the skilled direction of Peter Gardner during the last quarter of the nineteenth century. (From left to right) Posy vase demonstrating four different making techniques – throwing, modelling, moulding and cutting; jardinière in the shape of a Chinese three-legged moon toad; leaf-shaped dish in autumn colours; small vase with psychedelic glaze effects; and vase with cracquelure glazing.

Arts and Crafts

Even before the decline of the industrial potteries began, there were signs of an emergent Arts and Crafts movement which was to keep the tradition alive after the great era had receded into the past. Dunmore Pottery, which flourished during the last quarter of the nineteenth century, was hardly a craft pottery, but it contained some elements of one in its use of unorthodox shapes and spectacular glazes. The influence of Art Nouveau is apparent, if only slightly, in pieces such as relief vases of Nautilus porcelain, and even in some transfer prints, such as Bell's *Glenshee* pattern. The Port-Dundas Pottery, while concentrating most of its production on utilitarian stoneware, did reserve a little of its capacity at the end of the nineteenth century and beginning of the twentieth for artistic works, as did Buchan of Portobello with its so-called 'Portobello Faience'. Portents of what was to happen in the craft field can be seen in the exciting glazes of the Allander Pottery of Hugh Allan, which existed briefly at the start of the twentieth century at Milngavie near Glasgow.

The Art Deco movement found ready expression among the schools of studio pottery decorators which flourished between the two world wars, executing hand-painted designs on factory-made

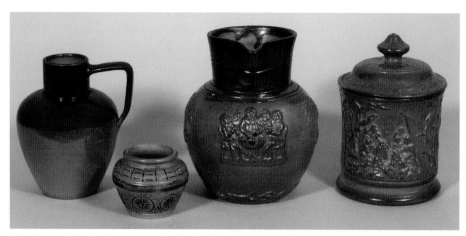

Four items of salt-glazed stoneware, by the Port-Dundas Pottery, Glasgow – Scotland's leading producer of this class of goods: (from left to right) a spoutless jug with severely simple lines; a small vase with blue-filled incised decoration; a large jug with sprigged scenes of hunting and carousing; and a moulded tobacco jar exhibiting camping scenes.

pots. Chief among these was Bough in Edinburgh, run by the talented Amour family, which had a long existence and a prolific output. Mak' Merry was operated by Catherine Blair at Hoprig Mains near Macmerry in East Lothian, where she advocated teaching women the techniques of craftwork so that they might discover their own latent talents. Stump at Longniddry, also in East Lothian, was run by William Watt, a disabled First World War

Three examples of high quality art stoneware by Buchan of Portobello, with the exotic (though inaccurate) brand name of 'Portobello Faience'. It was produced for a short period in the late 1880s and early 1890s. The sprigged application of differently coloured clays is reminiscent of Doulton's 'Silicon' ware.

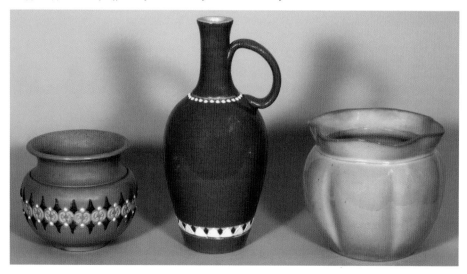

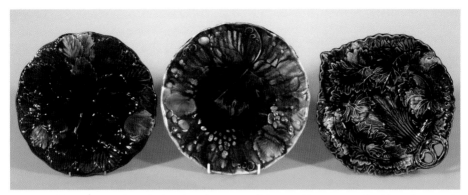

Three so-called majolica dishes, which perhaps bear a very slight resemblance to maiolica (the Italian term for tin-glazed earthenware). All bear relief patterns of leaves, and the central one includes the fruit of the vine; made by (left to right) Gardner's Dunmore Pottery, Bailey's Alloa Pottery, and Belfield's Prestonpans Pottery, the last being a registered design of 1876.

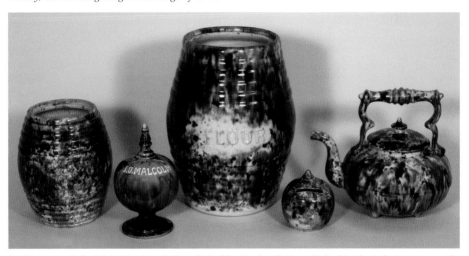

Spatter ware attributed to Morrison & Crawford of the Rosslyn Pottery, Kirkcaldy, the technique apparently involving dipping bunches of bracken in different coloured glazes and slapping them against the bisque-fired pottery. The larger of the two food storage barrels has the name of the commodity within applied in relief, and the taller of the two penny banks has likewise been personalised, using pipe clay. The tea kettle is an unusual object to receive this treatment.

veteran, who produced competent work without the benefit of a hand to hold his brushes. Zoo at Kirkcudbright, in the south-west, was worked by W. Miles Johnston, an art teacher from Edinburgh, who drew his inspiration from the animals he had befriended in the zoo. There were many others.

The principal industrial art pottery of the twentieth century was the Britannia Pottery in Glasgow. In the period 1920–34, it produced a large volume of striking wares, often using vivid colours on a cream-coloured body known as 'Scotch Ivory'.

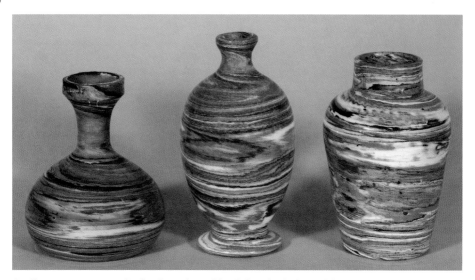

Small agate ware vases made of variegated pastel-hued clays, by Cochran of the Britannia Pottery, Glasgow.

Meanwhile in Edinburgh the Holyrood Pottery of Henry Wyse was developing a spectacular range of mottled glazes, achieved by replacing lead with copper and iron, and firing the ware directly in an open gas flame. The exciting results were to foreshadow some of the adventurous glazing techniques of half a century later.

From about 1950 onwards, as the industrial potteries declined almost to total extinction, so the individual craft potter came to the fore. A return to first principles brought a refreshing reappraisal of

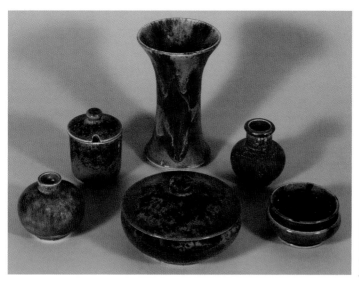

Group of small items by the Holyrood Pottery, Edinburgh, exhibiting striking glaze effects.

ancient skills. Function was translated into form with a direct honesty, and decoration became an integral part of the making process. Replacing the large centralised factory groupings, there arose over one hundred small potteries scattered throughout Scotland in a remarkably even spread, with just as many in Highland glens and on Atlantic islands as in the more populous areas. Some potters set up small factories, such as at Aviemore, Dunoon, Larbert, Montrose and Lybster. Most, however, preferred to run small craft potteries, usually single-person or husband-and-wife concerns, seeking and mastering new ceramic challenges.

Sometimes a redundant factory worker would tenaciously stay with their craft, and set up on their own account. A notable example of this practice is provided by Dorothy Clyde, formerly employed by Buchan of Portobello, who ran the Pyper's Wynd Pottery in Prestonpans between 1972 and 1993.

At least two potters worked in multi-disciplinary communes: David Heminsley at the Balbirnie Craft Centre in Fife, and Lotte Glob at Balnakeil Craft Village near Durness in Sutherland. Many, however, opted for solitude as well as remoteness, though it is perhaps surprising that so many chose to become island potters, considering the difficulties of transporting the kilns, obtaining raw materials and marketing the wares. One of the best-known was Alasdair Dunn from Arran, whose wheel sculpture (part thrown, part modelled while static) is reminiscent of, and sometimes even

Four elegant vases with intriguing effects, by (left to right) Belfield of Prestonpans (running glazes); Hugh Allan of the Allander Pottery at Milngavie, dated 1905, a forerunner of the modern craft movement (similar but more controlled); Clarke & Smith of the Seaton Pottery, Aberdeen (turned collar); and Cochran of the Britannia Pottery, Glasgow (marbling, gilding and enamelling) on a Chinese form of vase.

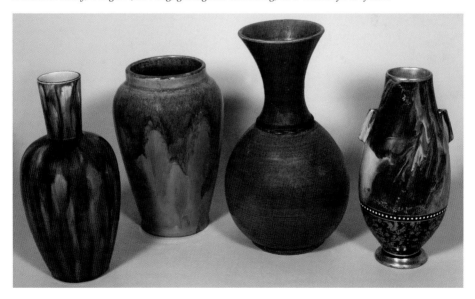

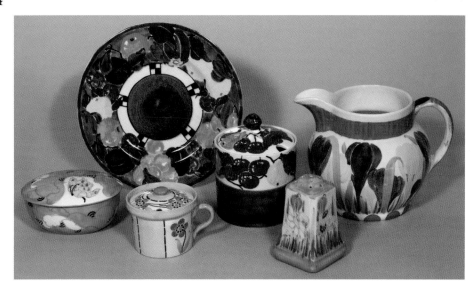

A selection from the decorative Bough studio in Edinburgh, where painting was done on pottery made elsewhere (the plate, for example, was made by Methven of Kirkcaldy). Members of the Amour family – represented here are Richard, Elizabeth and Chrissie – painted fruit and flowers in bright colours with the occasional inclusion of Art Deco motifs.

Five examples of the output of the many decorative studios which sprang up in the inter-war years. (From left to right) Stump – William Watt from Longniddry in East Lothian; Mak' Merry – Catherine Blair (and others) from Macmerry in East Lothian; Strathyre – Mary Ramsay (and others) from Perthshire; Zoo – W. Miles Johnston from Kirkcudbright; and Balloon – Violet Banks from Fife.

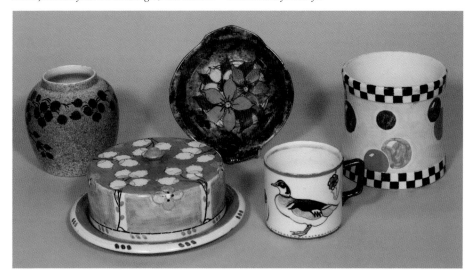

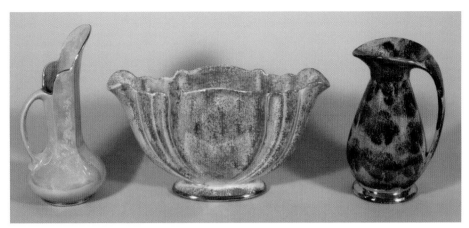

Three Art Deco items by the Govancroft Pottery, Glasgow, decorated by the technique of fluffy sponging, and also gilt banding.

incorporates, *art trouvé* from the high-water mark, blending the works of man and nature in dramatic fashion.

Of the many talented potters working in Scotland at this time, one of the most outstanding was Dave Cohen, who ran a pottery at Tantallon in East Lothian and also taught ceramics at Edinburgh College of Art. His throwing was skilful, his glazing subtle, his decoration superb, particularly when painting in metals, and his finished products, both technically and aesthetically, achieved a high degree of perfection.

Little creatures by Govancroft Pottery, Glasgow, exhibiting different types of decoration: a fish with sponging, a horse with all-over dipping, a frog with painting, and a squirrel with spraying.

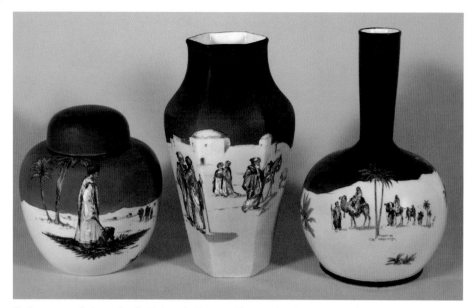

Various unusual shapes by the Britannia Pottery, Glasgow, bearing a series of designs featuring Arabs against a desert background, collectively appearing under the name 'Omar Khayyam', a trademark which the Pottery registered in 1923.

A selection of items from the final phase of the Britannia Pottery in Glasgow, which was the leading exponent of Art Deco ceramics. Some of these patterns were given names: the two on the left were known as 'Elfland' and 'Highland Vine', that on the right as 'San Toi'.

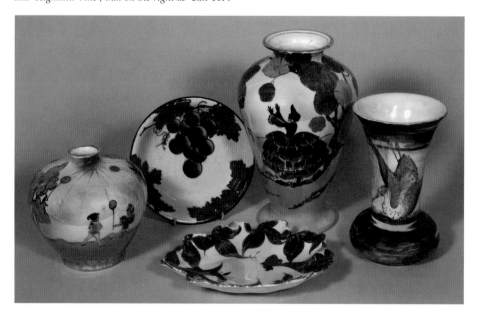

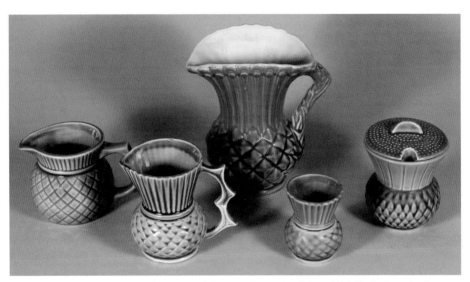

Thistle-shaped goods in natural colouring, made by several potteries: (left to right) Clyde Ceramics, Dunoon; West Highland Pottery, Dunoon; Govancroft Pottery, Glasgow (Highland Ware); Fear an eich, Coll Pottery, Isle of Lewis; Campsie Ware, Glasgow.

Patricia and Leonard Hassall (thrower and glazer respectively) of the Hand Pottery in Dunbar made pots which were often large and always intriguing in colour and texture. In the Old Smiddy at Gollanfield in Inverness-shire was the Culloden Pottery of Robert Park. His wide range of exciting shapes and his skilled application

Five examples of hand-painted stoneware with sprayed backgrounds by Buchan of Portobello, the patterns and the dates of their introduction being (on the left) 'Hebrides' (1958) and 'Iona' (1968), and (on the right) 'Edinburgh' (1961) and 'Sutherland' (1965). In the centre is the unnamed but immensely popular thistle pattern (1953), a major export line, from which the Pottery latterly took its name.

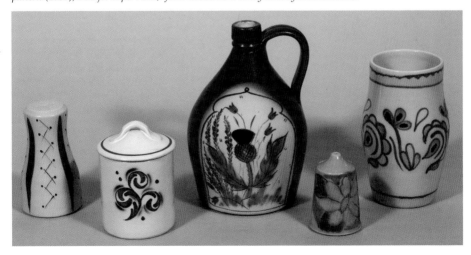

Three mantelshelf ornaments: a fish, a Scottie dog (Scottish terrier), and a bird in flight – Campsie Ware, Glasgow, the creation of Ted Langley.

of glazes (his own ash glaze being particularly effective) combined to provide a varied selection of highly appealing pottery. Tucked away in an almost idyllic situation near Kincardine O'Neil in Aberdeenshire was the Dess Station Pottery of Stewart Johnston, who was always prepared to try something different. His forms varied from the functional to the sculptural, and his own brand of glazes and decorative techniques always produced interesting results.

Many craft potters demonstrated a refreshing aptitude for experiment and innovation, while still remaining basically true to the fundamentals of pottery making. The sgraffito majolica bowls of Muriel MacIntyre at Nairn and the lustrous glazes of Margery Clinton at Haddington became leaders in their fields. The salt-glaze technique was revived by potters such as Ron Boyko at Craggan Mill Pottery near Grantown-on-Spey and Stuart Whatley of the Edinbane Pottery on the Isle of Skye, with striking results. A return to wood firing was fostered by Stephen Grieve at Crail Pottery in Fife and Warren Storch at Lawers Farm Pottery near Comrie in Perthshire. Wax-resist decoration was practised by Kenneth Annat at Bemersyde Pottery near Melrose, while Ian Hird at Kelso Pottery tackled the tricky raku process. Perhaps the most adventurous Scottish pottery was the Bongate Pottery in Jedburgh; for inventiveness in throwing, glazing and decorating, the work of Bernard and Nigel Hicken was unsurpassed.

Modern Scottish pottery has successfully blended sound age-old traditions with exciting innovations to produce a vigorous movement. It is intriguing to make comparisons: an Aberdeenshire beaker of around 2000 BC with a variant by Ian Hird of Kelso Pottery; a thirteenth-century baluster jug from Lanarkshire with a variant by Stewart Johnston of Dess Station Pottery in Aberdeenshire; a seventeenth-century salt-glazed wine jar from Berwickshire with a variant by Zelda Mowat of the Strathdon Pottery in Aberdeenshire; or a seventeenth-century round cooking

A varied group of modern craft pottery, by (left to right) Patricia and Leonard Hassall (Hand Pottery, Dunbar), Bob Park (Culloden Pottery, Inverness-shire), Alasdair Dunn (Isle of Arran), Janet Adam (Canonmills Pottery, Edinburgh), Stewart Johnston (Dess Station Pottery, Aberdeenshire), and Bernard and Nigel Hicken (Bongate Pottery, Jedburgh).

pot from Stirlingshire with a variant by Janet Adam of the Canon-mills Pottery in Edinburgh. In making these associations there is no suggestion that one is a copy of the other, but nevertheless the similarities in these pairings may be more than mere coincidence. Some of the present-day achievements may be truly novel, yet the tradition of the past lives on.

1

2

3

4 **5**

Five marks illustrating different methods of application. (1) Painted – a common way when the decoration itself is painted. The partnership involving members of the Geddes and Kidston families ran the Anderston Pottery in Glasgow between 1825 and 1834. (2) Impressed, using a metal die-stamp – often used when the wares were wheel-thrown in quantity. The partnership of William Clarke and Joseph Smith, two potters from Derbyshire who specialised in producing artistic vases, ran the Seaton Pottery for a brief period only (1904–5), making this one of the rarest marks in Scottish pottery. (3) Transfer-printed – the normal way when the pattern is printed. This example, by Bell of Glasgow, includes the pattern name within a cartouche that reflects the pattern itself, and also a registration device which dates 'Victoria Scroll' to 1850. (4) Rubber-stamped – used on a variety of goods, quite often on spongeware. This example by Methven of Kirkcaldy is fairly legible, though often this is not the case. (5) Incised, using a stylus – the most basic of all methods. The Cumnock Pottery (1792–1920), although operating during the industrial era, was essentially an old-style country pottery and, like its predecessors, very seldom marked its wares. Despite its prodigious output, marks like this one are most uncommon.

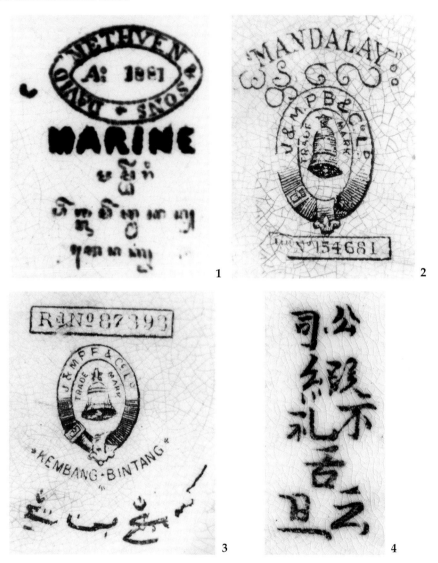

Four marks that include Eastern scripts, demonstrating that the items were made for export. (1) Javanese Jawi script by Methven of Kirkcaldy, though the pattern itself is Western in style. The mark, which includes the date 1881, wishes the diner 'Bon appetit'! (2) Burmese script by Bell of Glasgow, applied to a pattern which relates, in five instalments, a Burmese legend. The mark is a translation of the pattern name, being the second city of Burma; the pattern was registered in 1890. (3) Malay Arabic script by Bell, referring to a geometrical pattern. The mark translates as 'flower star'; the pattern was registered in 1887. (4) Chinese script, again by Bell, applied to a Chinese narrative scene, incongruously called 'Tamerlane' when for the home market but unnamed when exported (though it was made by other potteries in at least four European countries, all of which called it 'Timor' – an island in the East Indies). The maker of this piece is known because there is an impressed B in a bell elsewhere on the item. The mark is not easy to translate but seems to express a jocular sentiment which is unrelated to the scene; this product probably dates from the third quarter of the nineteenth century.

Further reading

The standard work, and indeed the only comprehensive book on the subject, is *Scottish Pottery* by Arnold Fleming (Maclehose, Jackson & Co, Glasgow, 1923, reprinted by EP Publishing Ltd, Wakefield, 1973). Written by a retired pottery manager rather than a historian, it has been shown to have many errors and omissions, but it contains a number of valuable first-hand accounts and it provides a record (albeit not wholly reliable) of information which otherwise might well have been lost forever. A more detailed book, though restricted in its area and period, is *Scottish East Coast Potteries 1750–1840* by Patrick McVeigh (John Donald Ltd, Edinburgh, 1979). This handsome publication contains many colour illustrations and much new information. However, the dating and attribution of many of the examples shown should be treated with caution. A lavish production which celebrates Scotland's most famous ceramic product is *Wemyss Ware* by Peter Davis and Robert Rankine (Scottish Academic Press, Edinburgh, 1986). A detailed study of *Kirkcaldy Potteries* (Fife Publicity, Kirkcaldy, 1998) by Carol McNeill concentrates on social rather than ceramic history. A very wide-ranging photographic survey of the products of the Scottish pottery industry appears in *Scottish Ceramics* by Henry Kelly (Schiffer Publishing Ltd, Atglen, Pennsylvania, USA, 1999), which also includes summaries of many of the firms involved.

A number of museums have held exhibitions of pottery produced in their areas, from which small publications resulted: Kirkcaldy in 1974, Bo'ness in 1977, Aberdeen in 1982 and 2004, Rutherglen in 1986, Prestongrange in 1990, Falkirk in 2002, and Stirling in 2002; also Prestonpans in 2007. Library services also have quite a good record of producing histories of potteries in their areas: Nautilus Porcelain (Glasgow, 1983), Clyde Pottery (Inverclyde, 1987), Alloa Pottery (Clackmannanshire, 1993), and Cumnock Pottery (Cumnock & Doon Valley, 1993). A series of booklets called 'Scottish Pottery Studies' was initiated in 1982, the aim of each being to examine some specific aspect of Scottish pottery history (for details, see below). The Scottish Pottery Society produces an annual magazine entitled *Scottish Pottery Historical Review*, which presents the latest research and comment (see www.scottishpotterysociety.co.uk).

BOOKS AND BOOKLETS BY GRAEME CRUICKSHANK

Scottish Spongeware. Scottish Pottery Studies No. 1, 1982 (out of print).

Scottish Saltglaze. Scottish Pottery Studies No. 2, 1982.

Campsie Ware. Scottish Pottery Studies No. 3, Glasgow City Libraries, 1992.

A Visit to Dunmore Pottery. Scottish Pottery Studies No. 4, Stirling Smith Art Gallery & Museum, 2002.

The Registered Designs of Belfield's Pottery, Prestonpans. Scottish Pottery Studies No. 5, Prestoungrange Arts Festival, 2007.

Prestonpans Porcelain. Scottish Pottery Studies No. 6, Prestoungrange Arts Festival, 2007.

Prestonpans Pottery; a Definitive Study. Prestoungrange Arts Festival, 2007.

A number of further booklets in this series are in various stages of preparation.

Places to visit

The following museums have interesting collections of Scottish pottery, but the proportion of a collection on display at any particular time can vary greatly; it is advisable to seek the current situation prior to making a visit.

Aberdeen Art Gallery and Museum, Schoolhill, Aberdeen AB10 1FQ. Telephone: 01224 523700. Website: www.aagm.co.uk A representative collection of Scottish pottery, including the local Seaton pottery, and Wemyss Ware.

Alloa Museum and Art Gallery, Speirs Centre, 29 Primrose Street, Alloa, Clackmannanshire FK10 1JJ. Telephone: 01259 216913. A collection of the local Alloa pottery.

Baird Institute, 3 Lugar Street, Cumnock, Ayrshire KA18 1AD. Telephone: 01290 421701. Website: www.eastayrshire.gov.uk An extensive collection of the local Cumnock pottery.

Callendar House, Callendar Park, Falkirk FK1 1YR. Telephone: 01324 503770. Website: www.falkirk.gov.uk/cultural/museums Collections of Bo'ness and Dunmore pottery from the area.

Glasgow Art Gallery and Museum, Kelvingrove, Glasgow G3 8AG. Telephone: 0141 276 9300 (Resource Centre). Website: www.glasgowmuseums.com Collections include local delftware and Nautilus porcelain, and Dunmore pottery.

Huntly House (The Museum of Edinburgh), 142 Canongate, Edinburgh EH8 8DD. Telephone: 0131 529 4143. Website: www.cac.org.uk A very extensive collection of the local Portobello pottery, including a reconstructed potter's workshop, and a representative collection of other Scottish wares, concentrating on those from south-east Scotland, including a spectacular collection of Wemyss Ware and many of the fittings from the Dunmore Pottery showroom.

John Hastie Museum, 8 Threestanes Road, Strathaven, Lanarkshire ML10 6DX. Telephone: 01357 521257. Website: www.southlanarkshire.gov.uk A mixed collection of Scottish pottery.

Kirkcaldy Museum and Art Gallery, Abbotshall Road, Kirkcaldy, Fife KY1 1YG. Telephone: 01592 412860. Website: www.fifedirect.org.uk A collection of varied wares from the local Kirkcaldy potteries, concentrating on the celebrated Wemyss Ware.

Marischal Museum, Marischal College, Broad Street, Aberdeen AB10 1YS. Telephone: 01224 274301. Website: www.abdn.ac.uk/diss/historic An extensive collection of the local Seaton pottery.

McLean Museum and Art Gallery, 15 Kelly Street, Greenock, Renfrewshire PA16 8JX. Telephone: 01475 715624. Website: www.inverclyde.gov.uk A collection of the local Clyde pottery.

McManus Galleries and Museum, Albert Square, Dundee DD1 1DA. Telephone: 01382 432084. A mixed collection of Scottish pottery.

Montrose Museum and Art Gallery, Panmure Place, Montrose, Angus DD10 8HE. Telephone: 01674 673232. Website: www.angus.gov.uk A collection of the local Dryleys pottery.

National Museum of Scotland, Chambers Street, Edinburgh EH1 1JF. Telephone: 0131 247 4422. Website: www.nms.ac.uk An extensive and wide-ranging collection from around Scotland, including many very special items.

People's Palace Museum, Glasgow Green, Glasgow G40 1AT. Telephone: 0141 271 2951. Website: www.glasgow.gov.uk Substantial collection of wares from many of the Glasgow potteries.

Perth Museum and Art Gallery, 78 George Street, Perth PH1 5LB. Telephone: 01738 632488. Website: www.perthshire.com Mixed collection, concentrating on studio pottery made in Perthshire in the late twentieth century.

Prestongrange Museum, Morrison's Haven, by Prestonpans, East Lothian EH41 3PJ. Telephone: 0131 653 2904. Website: www.eastlothian.gov.uk Collection from the local potteries in the Prestonpans area.

Smith Art Gallery and Museum, Dumbarton Road, Stirling FK8 2RQ. Telephone: 01786 471917. Website: www.smithartgallery.demon.co.uk A mixed collection of Scottish pottery, concentrating on the famous Dunmore pottery from Stirlingshire.

Index

Page numbers in italic refer to illustrations